THE GALLERY

MANAGEMENT

MANUAL

THE GALLERY

MANAGEMENT

MANUAL

by Zella Jackson

THE CONSULTANT PRESS, LTD.
New York, New York

PUBLISHED BY:
THE CONSULTANT PRESS
163 AMSTERDAM AVENUE
NEW YORK, NEW YORK 10023
(212) 838-8640

Library of Congress Number 94-068452

ISBN 0-913069-50-7

Printed and bound in the United States Of America

TABLE OF CONTENTS

INTRODUCTION

In *The Gallery Management Manual* we will explore management as it relates to a successful sales program. Successful sales management in a gallery setting involves the administration of three essential elements — Personnel, Planning and Persistence. They are the keys to increased sales and profits.

It is all too easy to ignore one or more of these essential elements. You must discipline yourself to apply all three or you will be conducting business under a handicap.

Planning, Personnel and Persistence are factors applicable to private dealers, small galleries, and multilocation dealers. If you are a private dealer you may be tempted to skip the chapters on personnel. They contain, however, ideas that are essential for you to adopt even if the you wear multiple hats, i.e., owner, director, manager, and salesperson.

Rely on your accountant and attorney for advice on the required record keeping relating to financial statements, taxes, and business law. The records referred to in this manual relate to records necessary to increase your sales of art.

The examples in the text presuppose an art business with gallery space and with four art professionals. If you are a private dealer or your gallery and staff is smaller or larger, you can take full advantage of the recommendations by making the common sense modifications necessary to fit your situation.

Many of you have probably read or own my other two books *The Art Of Selling Art (Second Edition)* and *The Art of Creating Collectors*. There are several pages of this volume that repeat material covered in those works. The reason for the duplication is twofold. The first is that each book is designed to be used without reference to the other books although all three are valuable to anyone in the profession of selling art. The second reason

is that the material repeated is so critical to success that the reinforcement provided by repetition is valuable.

The examples of dialogues and forms are appropriate for many art professionals but may require modification for others. The materials are meant to be examples not dogma. The only dogma is that you must focus on Personnel, Planning and Persistence in order to develop and sustain successful selling programs.

The organization of this manual is partly based on the importance of the material being presented. You will thus find *Motivating Your Sales Team* as Chapter One because I consider it to be of major importance. It is the foundation for success. You can recruit and/or train superior art consultants but you must continually keep them motivated. Similarly your planning will come to naught if your art consultants don't follow through. They must be motivated. You are going to ask them to be persistent in their efforts. They will not be persistent if they are not motivated!

Zella Jackson

CHAPTER ONE

MOTIVATING YOUR SALES TEAM

Whether your sales team is composed of one, two, or ten art consultants, incentives that provide motivation are the key to success. Incentives are required because:

- Sales people, especially art consultants, hear more *no's* in a month than many people hear in a life-time. Incentives designed and awarded properly help buoy human spirits.

- Sales performance rarely slides backwards (aside from short term slumps). If you can motivate each art professional to stretch for new, higher levels of sales — they will never regress. Even when the economy slumps, your art professionals will find their confidence strengthened and motivation increased by appropriate incentives. Thus the effect of an economic slump on your sales can be tempered.

The challenge in designing incentives for any team revolve around your understanding of your team as well as yourself. What are the psychological profiles of all the key players? An incentive program that will work wonders for a cohesive, *all for one/one for all* team would be a disaster for an individualistic, entrepreneurial team.

First make an assessment of your team and yourself. You can simply use your intuition, conduct interviews as part of your one-on-one meetings, and/or have each person complete a brief personality profile. Hundreds of such profiles exist on the market and while woefully inadequate for any serious psychological counseling, they can be very helpful in the workplace. This is particularly true with overview issues such as determining those in your team who are task oriented vs. people oriented — self directed vs. team directed.

For the self-directed/task oriented team, incentives that reward the individual as opposed to the group effort are more valued and effective. For example, establish thresholds of monthly sales performance, e.g., $10,000, $15,000 and $20,000 under which each consultant who achieves a threshold will all receive identical cash bonuses. This will appeal to the self-directed/task oriented team because each team member has an opportunity for a personal reward along with individualized recognition. This fosters a positive attitude toward incentive programs because each person is competing only with themselves.

A common mistake managers make with the self-directed/task oriented team is to have what I call *one-only* awards, i.e. the person selling the most this month will receive the incentive reward. While used frequently, *one-only* awards can at best create a climate of silent resignation, and at worst, stimulate unhealthy competition and resentment.

The reason is that in many galleries everyone knows who the winner will be before the month starts. It is not uncommon to have one star sales person who seems to have a loyal and ever increasing following. The result is that no one else strives to win the award. In addition all the non-winners become resentful because they *never* get a chance to win. Thus the incentive program is counter productive.

For the team that is people oriented/team directed, the award should be for the team.

Incentives may range from vacation trips to theatre or concert tickets coupled with dinner at a three star restaurant. The incentives should match the interests and needs your art professionals. The permutations and combinations of incentive awards are limited only by the dollar amount you allocate. For many individuals two theatre tickets and dinner for two is more meaningful than the cash equivalent. The opportunity to win a gallery paid vacation week with their significant other in New York or Honolulu may be more of an incentive than a cash bonus.

The focal point of every sales meeting should revolve around giving out awards for the last incentive program and detailing the criteria for the one that starts today! This will enable you to capitalize on positive synergy.

It is a fact of life that most of us experience exaggerated responses when part of a group — think of adoring fans at a concert or a baseball game. As a manager, why not choreograph a positive fever pitch to launch everyone off onto the next promotion? Unhappily, many sales meetings are fraught with negative details (Why won't you complete the sales invoices, answer the phone properly, show-up on time, call enough people?). If you follow that scenario you will leave the entire group in a downward spiral of exaggerated proportions. Think about it!

Additional Ideas For Self-Directed/Task Oriented Teams

- When you conduct direct-mail and phone campaigns (including exhibitions), award a cash bonus to all who sell specific quantities of the multiple work featured in the promotion. For example, all those who sell five of the ABC sculpture will receive a specified dollar bonus; those selling ten will receive twice as much, and so on.

- For a specified time period such as 30 or 90 days provide *Gallery Dollars* as bonuses. These *dollars* can be applied toward the acquisition of art. A plus factor in using this incentive is that you will stimulate your team members to become art collectors. Being collectors will, in turn, have a positive effect on their sales.

- Establish short term incentives (weekly or monthly) and long term incentives

(quarterly or yearly). The long term incentives involve cumulative sales results. Thus, each new award is above and beyond those which have already been awarded. Awarding travel packages is a good incentive that people are willing to work extended periods for (as long as some interim bonuses are provided). One of my clients established low, medium, and high thresholds and offered each person attaining one of the levels a low, medium, and high priced travel package. Because the team was composed of primarily young, less traveled individuals, this incentive worked extremely well. Travel also expands peoples' minds and makes them even more confident on the sales floor, particularly when confronted with an older, wealthy person who is well traveled.

For the people oriented/team directed team, incentives that reward the group above the individual are more valued. For example, if everyone achieves a minimum threshold and the total exceeds a fixed dollar minimum, then the entire team will win a trip. This will appeal to such a team because each person has an opportunity to contribute to the larger effort and will benefit from the group award. Moreover, a group award, such as a trip, will be inspiring because the team cherishes group experiences.

Additional Ideas For People Oriented/Team Directed Teams

- For each exhibition establish a minimum sales threshold. When the total exceeds the threshold amount, the entire team will be awarded dinner at an extraordinary restaurant.

- To make your direct mail and phone campaigns more successful, offer each team member the multiple artwork promoted when a specified sales level is achieved. Again, depending on the specific individuals involved, you may wish to have a minimum sales level threshold. This is particularly true if one or two team members are so new that their contribution will be minimal or non-existent. If the team has coalesced over a long period then minimum thresholds may not be necessary.

- Once a pre-specified sales level is achieved over an extended period, the team will have the use of a new van, microwave oven, new desks, new carpet in the gallery, etc.

- Once a pre-specified sales level is achieved, a gallery sponsored and paid visit to a famous artist's studio may be scheduled. Sometimes you can even tie it entirely into the sales results achieved solely for the artist and in turn, have a cooperatively sponsored event. For such

events, the artist can often be persuaded
to provide special gifts for each person on
the team at the time of the event. The gifts
may include prints with a remarque
commemorating the event, miniature
originals with personalized messages from
the artist on the verso, or books by the
artist with personalized inscriptions.

The examples above should assist you in stimulating your team to greater heights. In general, keep the entire format light-hearted and fun. If you find yourself in doubt about what would be most inspiring, ask your team members for feedback. While written feedback may be hard to come by, I have found the salespeople are always eager to talk about potential incentive plans.

One important thing to remember is that nothing external motivates people. We are all motivated from within. Sometimes jargon and commonly used phraseology confuses this very important issue. Every elementary psychology book tells us that human beings are motivated *from within* by deep-seated psychological needs. The best a manager can do is be sensitive those needs and provide an environment that is conducive for each person to motivate him/herself. The external incentive is merely the catalyst for the internal motivation.

Announcing an Incentive Program

I use three key words to describe a recommended incentive program announcement format — *Excitement, Anticipation, and Applause.*

- Excitement: You create and build the
 excitement. If you are not excited, believe
 me, no one else will be. Make certain the
 incentive is as significant as possible. As
 long as the additional sales are achieved,

the cost of the awards is covered. In fact, once you pass your break-even point (all your fixed costs are covered) it behooves the owner to reward the consultants as much as possible. An extravagant incentive will help build the fervor. Use visuals and strategically timed leaks regarding the incentives at sales meetings.

- Anticipation: Don't let anyone know the entire incentive package until the announcement at the sales meeting. Remember, the earlier leaks are teasers, not the complete story. They should be just enough to keep the sales team buzzing about the possibilities. To play it best, always make the final announcement *better* than anything they have heard.

- Applause: After the final announcement, ask the group if they are excited about the incentive. Boldly solicit applause, especially if there are only three or four of you. And as you sequence through each new incentive program there will be lots of applause throughout your meetings. The group will applaud each winner and/or the team's achievements, and now the next incentive. What an upper your sales meetings will become! I am willing to bet that any trouble you may have had getting sales people to sales meetings or having them be on time, will all but disappear.

Designing incentives should be an enjoyable experience. Even more rewarding is awarding the bonuses. If you simply use a little imagination, put yourself in teams' shoes, and make the incentives as lucrative as possible — everyone involved, particularly you, will be happier and derive a greater sense of job satisfaction. Afterall, recognition for a job well done is what incentives are all about.

What About The Sales Manager?

The Sales Manager (the typical title in a sole proprietorship or partnership) or Vice President of Marketing and Sales (the typical title for an incorporated firm) should have the opportunity to earn a substantial income. The sales team needs a leader who is successful. They will respect and emulate the leader's success.

The Sales Manager should not compete with the team. A solid base salary plus a percentage over-ride on all sales is appropriate if, (1) the business is sufficiently mature and/or well capitalized, (2) the Sales Manager has a successful track record in sales and sales management and (3) the Sales Manager has personnel management responsibilities including hiring, firing, and on-the-job training duties.

What About the Private Dealer?

If you are a private dealer with no staff you can benefit from incentives. The key is to choose something you desire. Choose to treat yourself and your significant other to New Orleans during Mardi Gras week or to a week of theatre in London. Choose to trade in your three year old car for a more luxurious model or to acquire a new set of golf clubs. Set a sales goal and award yourself the incentive only when the goal is achieved. Write down your goal, your incentive, and the time frame. Adhere to the terms. It works!

CHAPTER TWO

TEAM SELLING

The Team Selling Option

Team selling is a variation on the popular although sometimes abused turn-over ("T.O.") process. I have taken the positive aspects of the concept and updated it with a twenty first century *win-win* philosophy:

The team selling option involves the sales manager, senior, junior, and trainee art consultants working together as a team to fulfill the firm's goals. The primary goal is to close a larger percentage of walk-ins and appointments while enhancing the firm's image and reputation.

The method by which the primary goal is accomplished is through a strong understanding among all the consultants as to how to greet, qualify, and introduce sales support personnel.

The Key Steps of Team Selling

1. Art consultant turns over to manager or manager interjects

2. Art consultant introduces and re-caps

3. Manager takes the lead

4. Manager introduces and re-caps

5. Manager handles objections

6. Manager negotiates the close

7. Manager turns back to art consultant (present entire time)

8. Art consultant concludes the sale

Sample Script - Art Consultant T.O. to Manager

A. Qualify the person as before you bring in the manager. You should know the following:

 1. current art collector (Y/N)

 2. current art collection content & value

 3. professional/business status

 4. name

 5. marital status

 6. tourist or resident (resort towns & conventions)

 7. residence area or hotel

B. Proceed as far along as you feel comfortable (preferably into the dimmer room or seated close to their main interest):

C. Art Consultant makes the decision — Yes, I am going to bring the manager in.

D. At a comfortable moment, bring the manager in:

 • The client asks a question (you may or may not know the answer) and you offer to bring in an expert.

 -or-

 • You begin to explain a key area and offer to bring in an expert for elaboration.

E. Always give an upbeat glowing introduction:

Well, Mrs. Jones, you seem extremely knowledgeable about art history and the period we have been discussing. I would like

to introduce you to my manager, Nicola Taylor. She is our authority in residence on the cultural ramifications on art during that period. Here, sit down and relax — I'll get Nicola immediately.

F. Recap all pertinent information to the manager:

Nicola, I would like to introduce you to Mrs. Jones. She already has an extensive art collection including some fine 19th century prints and antique Japanese wood block prints. Her lovely summer home in Marin might have a place for (title of artwork) but she requires a little more information on the cultural influences that shaped the movement. I told her you were the expert! Oh, by the way, Mrs. Jones also has a masters degree in history.

G. Manager takes the lead:

Fantastic, what a pleasure to meet you (shake hands when comfortable). I would be happy to share (subject) as it relates to (title of artwork) with you.

H. Manager takes the lead:

Well, as Robert may have shared, I have been with the company for over (fill in the blank) years. I have had the opportunity to travel to Europe, Japan, New York, Florida, Chicago, Atlanta, as well as on the west coast — all over really — with the owners and our artists. I have learned so much about (subject). So, you love (title of artwork)..... [continue sales presentation with dialogue and interplay]

I. Manager handles objections.

J. Manager negotiates the close.

K. Manager TO's back to the art consultant who has been present the entire time:

Well, congratulations Mrs. Jones. You are now the proud owner of (title of artwork). [Shake hands} As you know, Robert will be concluding the paperwork for you today. He will keep you informed of upcoming events and promotions as well.... would you like that? (Dialogue) Of course! Oh, by the way, Robert, don't you think Mrs. Jones should get an invitation to (name the show/event)? Great! Well, thank you again, Mrs. Jones, it has been a pleasure.

L. Art Consultant concludes the sale:

- Initial paperwork - time frame for delivery and add ons

- Commitment to recontact at a specific time

- Home and office addresses as well as all phone numbers

Sample Script - Manager Interjects

A. Manager makes the decision — *I am going to interject when*:

- Buying signals are being missed by the art consultant

- A couple is separated and are not focused

- Art Consultant's sales presentation is not substantive or persuasive enough due to newness, having a bad day, etc.

- Manager detects a personality conflict

- A walk-in is leaving the gallery and insufficient qualifying has been completed

B. Manager introduces and takes the lead:

John I couldn't help notice this gentlemen's excitement about (title of artwork). You are really taken with this image, aren't you? (Dialogue) Of course! Allow me to introduce myself. I am Nicola Taylor, the Gallery Manager and I would love the opportunity to share some insights I have about the artist's inspiration for this piece.

-or-

John, I could not help but overhear your client's question about (subject). You know, I was just at a manager's meeting this morning and I have some new information we need to share.

Art Consultant responds:

Great! Well, let me introduce you to Mr. Micheal Jordan. He has been an admirer of (name the artist) for a long time but has yet to acquire one. Mike prefers original paintings over reproductions and has collected a few important pieces — a McKnight original, a Pascal glass sculpture which is quite rare and a few others. Mike is visiting from Missouri and will be here until Friday out at (name the four star hotel). And, Mike, this is Nicola Taylor, our Gallery Manager. She is our expert (subject). I am certain you are going to enjoy what she has to share.

Pick up at G and go to L as in previous script.

In summary, team selling is certainly an option for many art firms. Sales teams that are people oriented/team directed will benefit most from fine tuning the format so it works well in your gallery.

CHAPTER THREE

THE ORGANIZER — THE KEY TO PLANNING AND PERSISTENCE

Planning and persistence are tow of the three the keys to successful gallery management. Planning and persistence require the use of written lists of appointments, events, reminder notes, names, phone numbers and other relevant data. The number of individuals who can retain their daily, weekly, monthly, and rolling thirteen month calendars together with phone numbers, names and best time to call in their heads ranges from slim to none.

The use of a series of written records which I refer to collectively as an organizer is mandatory. Any organizer is satisfactory as long as certain basic components exist. There are many off-the-shelf organizers available but they do not all contain the same components. Computers with desktop publishing and/or form software (See Chapter Four) facilitate the production of custom organizers for use in your gallery.

The Essential Components

I encourage art professionals to have available in their organizers the following components:

1. a thirteen month rolling calendar

2. macro to micro goal setting forms

3. a filing arrangement that allows straightforward client contacts

4. forms to record data — eliminates need to remember details

5. cross-referenced and easily accessible client information

The purpose of an organizer with the recommended components is to assist each art professional in the firm in systematically:

1. obtaining repeat business,

2. closing deliberative thinkers (who make up 60 to 65% of the art buying public),

3. expanding his/her client list by obtaining referrals,

4. conducting targeted phone campaigns,

5. conducting targeted mailings,

6. setting short and long range goals, and

7. organizing detailed client information for easy access.

The organizer I developed and have sold for years at the various art trade shows, and via mail order makes use of thirteen basic forms. Some are universal such as a month-at-a-glance or an annual calendar. Others are specifically adapted to the art business.

I have used a few forms in this chapter to illustrate how to organize for the planning and persistence aspects of successful gallery management. The forms are examples of proven ways to organize client records and have been used by successful art professionals across the country for years. Let us visit the all important *Client Information Sheet*.

Client Information Sheet

The upper left hand corner of the *Client Information Sheet* (reproduced at page 27) is perfectly suited for you to staple a client's business card. Once you adopt the habit of asking for business cards you realize how it eliminates many potential problems such as spelling errors, awkwardness in obtaining address and phone numbers, omission errors (e.g. zip codes).

The business card is also "permission to call the person at work" and all that is left is to find out the best time to make a phone appointments (and whether the home phone is an acceptable alternative). The remaining sections of the form are self explanatory.

The important thing to remember about the *Communication Log* portion is that 200 to 300 of such forms filled out empower you to be influential with a much wider range of people than you could possibly sell to without such records.

Just prior to any phone call or meeting with a collector, review the back of the *Client Information Sheet*. It will allow you the opportunity for more rapport building when you interject personal elements that would otherwise escape your memory.

Making a note of credit card numbers and expiration dates expedites your transactions with your collectors. This data can be recorded in the *Other* section.

Deciding ahead of time, what potential artwork you will recommend will aid you successfully folding the client into your on-going marketing and sales efforts.

In addition to the efficiency features noted, the client information sheet affords art professionals the opportunity manage large numbers of collectors effectively. As a guideline, even a novice art seller working in a moderately trafficked gallery should be able, in a twelve month period, to accumulate client information sheets on 75 or more prior buyers .

Note that good managers provide orphan clients to art professionals. An orphan client is a prior buyer who acquired artwork from an art seller no longer with the firm. Thus, a determined professional assuming modest sales results may reasonably expect 100 to 125 prior buyers worthy of close attention and follow-up (i.e. 75 of his/her own and the balance in orphans). The neophyte will have amassed 125 client information sheets in the first year!

An experienced art seller should be able to manage 200 to 500 prior buyers pretty handily even with a manual paper system (a greater number may require using a computerized system). At some point the focus of each art professional will change from obtaining a greater number of buyers to closing transactions with a higher average invoice price per transaction.

Thus, three years into the profession a collector base for an art consultant may be comprised of 300 clients with average invoice amounts of $5,000. That should result in compensation of roughly $90,000 if we assume each client bought one average priced art work per year. A talented professional will increase both the number of collectors and the dollar amount of the sales.

Client Information

Name:_____

Address:_____

City:_____ State:____ Zip:_____

Phone (R):_____

Phone (O):_____

Fax:_____

Best time to call:_____

Communication Log

Date	Reason for Contact	Commitment Date(s)	Action Taken	Next Contact Date

Client Profile

Decision maker(s):_____

Current art collection:_____

Primary buying motive(s): Emotion ☐ Investment ☐ Decor ☐ Other ☐

Buying style: Impulsive ☐ Deliberative ☐ _____

Annual income (estimate/actual):_____

Important family members & business associates:_____

Important dates:_____

Other comments:_____

Purchase History

Date	Invoice #	Art work(s) Acquired - Artist - Title Description	Price	Layaway	Shipment Date

Art Sales Goal: $_____ Future Acquisitions:_____

For the year 19___ _____

Communication Log

Date	Reason for Contact	Commitment Date(s)	Action Taken	Next Contact Date

Notes

Efficient Use Of Schedules And Tallies

Major shows are documented well in advance and appear on an *Annual Show Calendar* and/or a *Thirteen Month Rolling Calendar*. The schedule is merely your listing, by month and week, of your exhibitions and promotions. The purpose of using a 13 month rolling calendar is to avoid the trap of coming to the end of a calendar year without having planned your schedule for the following 12 months.

Tally sheets such as show organizers, artist sales tally, and lay-a-way-tally should be used to systematically compile clients' names in meaningful groupings that allow easy follow-up for high sales levels. Examples are provided on the following pages.

The *Show Organizer Form* contains data relating to a single show and the names of potential attendees. As clients and prospects are introduced to the idea of attending a future show, your art professionals will develop the habit of specifying the particular upcoming exhibition. In so doing, over a period of three months, they can easily add name after name onto each show organizer form until you have 20 to 40 highly motivated attendees.

Once a specific exhibition date approaches, you move the now full sheet to the top of your file, the beginning of your organizer, or to computer print-out for the current month. It is then utilized as the record for follow-up on all those previously motivated to attend the show. In fact, it would be wise to photocopy the tally and use the copy as your call sheet when confirming attendance. This way the original copy of tally can continually be augmented with new names. The original will be ready for use in connection with the next relevant exhibition.

The artist tally and lay-a-way tally are used in the same fashion. Adopt existing organizer forms or design forms specific to your gallery. Remember that the goal in using an organizer system is not to compile information but to organize the information so that it may be used to facilitate the sales of art. As a manger you should use an organizer and mandate the use of organizers by your art consultants.

THIRTEEN MONTH ROLLING CALENDAR OF EVENTS

	1ST WEEK	2ND WEEK	3RD WEEK	4TH WEEK
JAN				
FEB				
MARCH				
APRIL				
MAY				
JUNE				
JULY				
AUG				
SEPT				
OCT				
NOV				
DEC				
JAN				

The idea behind a thirteen month rolling calendar is that the current month is always at the top and the subsequent twelve months follow. This form of calendar is a constant reminder to constantly plan ahead for a full 12 month period **from** the current month.

ANNUAL CALENDAR

(With sample entries - 6 shows)

JAN	
FEB	2/5 Hart Mail/Phone Promotion
MAR	
APR	4/20 Neiman Mail/Phone Show & Promotion
MAY	
JUN	6/20 Erte' Mail/Phone Promotion
JULY	
AUG	8/10 Gallo Mail/Phone Promotion
SEPT	
OCT	10/15 Otsuka Mail/Phone Show & Promotion
NOV	11/29 Christmas Cards to Special Clients
DEC	12/1 Angelo Christmas Mail/Phone Show & Promotion

Annual Promotion Budget

	PROJECTED $	ACTUAL $
ON-SITE EVENTS		
Show Invitations		
Refreshments & Food		
Props		
Plants & Flowers		
Signage		
OFF-SITE EVENTS		
Facilities Rentals		
Equipment Rentals		
Shipping/freight Charges		
Airfare/Transportation Costs		
Signage		
ON-GOING		
Signage		
Props		
Plants & Flowers		
Lighting		
Portable Walls		
SALES COLLATERAL		
Portfolio		
Photographs		
Brochures		
MAIL/PHONE CAMPAIGNS		
Postage		
Envelopes/Stationery		
Long Distance Phone Charges		
MAGAZINE/NEWSPAPER ADS		
TOTAL		

WEEKLY MANAGEMENT CHECKLIST

MONTH:_____

SOURCE	WEEK:	1	2	3	4	5
() SALES Last week:		$ _____	_____	_____	_____	_____
() SALES Month-to-date:		$ _____	_____	_____	_____	_____
() SALES This month last year:		$ _____	_____	_____	_____	_____
() SALES Year to date:		$ _____	_____	_____	_____	_____
() SALES Year to date target:		$ _____	_____	_____	_____	_____
() Promotion projects behind schedule:		# _____	_____	_____	_____	_____
() Return on net sales Year-to-date:		% _____	_____	_____	_____	_____
() Projects under consideration:		# _____	_____	_____	_____	_____
() Projects in pipeline:		# _____	_____	_____	_____	_____
() Projects behind schedule:		# _____	_____	_____	_____	_____
() New projects in planning:		# _____	_____	_____	_____	_____
() Major prints/Framed Artwork behind schedule:		# _____	_____	_____	_____	_____
() Oldest unfilled order:		# _____	_____	_____	_____	_____
() Accounts receivable over 90 days:		% _____	_____	_____	_____	_____
() Supply items not in inventory:		# _____	_____	_____	_____	_____
() Equipment items not functional:		# _____	_____	_____	_____	_____

CHAPTER FOUR

THE COMPUTER AND GALLERY MANAGEMENT

Computers are no longer a luxury nor devices used solely by those with a high degree of technical proficiency. Computers have joined the ranks of copiers and fax machines as essential office equipment.

The decision as to how a computer is used in your gallery or private dealership is the only open question. Whether you use it to merely to facilitate correspondence and invoicing or as an integral part of the organizer system is a personal decision. It is clear that the larger your staff and the larger your client base, the more important the computer becomes as a tool.

I continue to be amazed at the power a single individual can have at his/her finger tips. As I write this sentence on a oversized monitor attached to my computer I can scan one and a half pages of text. Moreover, while I am using MicroSoft Word™ to compose this book because that is standard in our office my publisher has stipulated that I must provide the text on diskettes in WordPerfect™. That, of course, is no problem because I will use a conversion program that in minutes will convert the entire book into WordPerfect™.

This once computer phobic person has incorporated modern computer technology into her professional life. My husband has carried this into our personal lives to an incredible degree. For a recent vacation, he searched for the lowest airfares available on his lap top computer, booked our reservations, and paid for the tickets. We received the tickets via mail within two days! He also uses Checkfree which allows us to pay most of our bills electronically — automatically each month!

If you haven't computerized your business yet, then I strongly recommend you do so. Most applications useful to the small business owner are straightforward to learn. The manuals are continually improved and are truly useful reference tools. Software is available for every area of

your endeavors. If you are a computer phobic and/or and are uninformed about hardware and software choices then you are wise to tread slowly.

There are many successful art firms who have opted to stick with paper systems for client records, inventory, accounts payable, accounts receivable, general ledger, payroll, correspondence and mailing lists. I suggest however, that they are not nearly as successful as they might be if they employed computers.

With that in mind, review the following.

Are There Precautions To Take Before Buying A Computer System?

The answer, of course, is yes. In fact computer systems may be so improperly implemented that they end up taking more of your time than they are worth. The two main reasons for this are: (1) poor advice, and (2) acquiring the computer before deciding on the software.

1. Poor Advice

If a computer salesperson, friend, or possibly even yourself — guides your decisions without the proper experience and expertise — you are more likely to make a costly mistakes. Poor advice may lead you to make decisions that will cost you valuable time and resources. In some cases, you and your team may very well be turned off from computers — wounds will take time to heal before any renewed attempts are made to computerize — if at all.

A typical scenario — The owner's brother-in-law, Dave, is a computer hobbyist who is proficient at desktop publishing. The owner feels confident that Dave will provide good, free advice. Unfortunately Dave has little knowledge or experience of what is appropriate for a small business including hardware configurations and software requirements and the impact on personnel. Dave is an English teacher by profession and knows little or nothing about running a gallery.

Dave recommends the computer that he last purchased and the latest version of a brand name office suite (i.e. word processor, database, and spread sheet programs sold together in a package). Unfortunately although the database and word processor are appropriate for a mailing list and correspondence, the development of an invoicing system, inventory system, and other systems appropriate to the gallery will require a steep learning curve and an inordinate amount of time spent by gallery staff.

Dave, even though he reads two computer magazines each month, wasn't even aware of the availability of software programs that have been specifically written for gallery management. It isn't Dave's fault, gallery management programs are neither advertised nor reviewed in the mass market computer magazines.

The point of the story is simply this, when obtaining advice for something as important as your business (which creates the income for your livelihood) — rely on someone who understands what you require and is familiar with what is available. That person may be another gallery owner or a consultant who has successfully completed software and computer installations similar to that which you require.

That old adage, *Free advice is worth what you pay for it*, is never more true than in the computer world. Seek out a computer consultant who will give you a firm quote for a needs assessment. The needs assessment should be in a written report (clearly indicating the consultant's prior experience in the field) and recommending at least two software and hardware options with the advantages and disadvantages of each clearly spelled out together with the cost.

Prior to engaging an expert, ask for a list of prior clients. Call at least three whose business is similar to that of your firm. Ask if the consultant managed the installation, came in at or under budget, worked well with the staff, provided instruction to the data entry person(s) to ensure relative self-sufficiency, provided informative manuals to support the software, and

recommended hardware that could be serviced locally. Inquire as to the nature of the third part hardware service.

2. Select Your Software First

Imagine buying a car that had just the right specifications — engine size, horsepower, front wheel drive, and color but could only comfortably seat four while you have a six in your family! Well, sadly to say, most people buy their computer systems in much the same manner. First, they become enraptured a friend's recommendation regarding hard drive size, operating system and available RAM. But when all is said and done, unless you select your software first, you may find yourself with a computer that will not be able to run the best software for your business.

The most fundamental problem is that all computers do not run all software. The best program for you may only run on PC but you have acquired a Macintosh™. You have acquired a PC with insufficient RAM to run the best program or a bargain 386 when the program requires a 486. Yes, you can add RAM or upgrade chips but is always more expensive to upgrade than to obtain what you require at the time of original purchase.

It is the software that will determine how well you automate your paper flow and how comfortably the system fits your way of doing business. Thus, do your research, with the help of a professional if necessary, in order to ascertain software that will work best for you . . . then select your hardware.

All but the very largest art firms will benefit most from selecting specialized software that is off-the-shelf and sold nationally. This is true because most of the bugs in off the shelf programs have been eliminated and comprehensive manuals have been written. You will be able to obtain a verifiable list of satisfied users. The cost of the installation of off-the-shelf software, as compared to a custom job, is significantly lower. In addition there will be a greater ease of the installation and staff training will be shorter. These are major benefits for small to medium sized art firms.

A software package for an art firm should to be able to track your consigned inventory, automatically create separate inventory entries for multiple editions, maintain purchase histories and client dossiers, track the artists and types of artwork purchased, and feature fully integrated updating of all related records. It should be able perform other functions specific to your art business.

If you will pardon nepotism, I mention that my husband Larry Underhill, has spent the last twelve years writing custom software, manuals, and training operations personnel and their managers. He provides follow up support on a contract and on an as-needed basis for small to medium sized firms. He has standardized several software packages and successfully sold them on a national basis including one, not surprisingly, specifically designed for art firms. I have witnessed far more closely than most, the agonies and ecstasies of software/hardware installations. A call to Larry at 1-800-753-4337 may result in answers to your questions. Good luck and happy computing.

At this point you may ask why I don't recommend several packages of computers and compatible software. It is a good question and the answer is that computers and software are continually being improved, upgraded, and fine tuned. Between the time I wrote the first draft of this book and it was finally edited, a generation of hardware and software came into being and passed into the category of outdated technology.

When is Manual/Paper System a Viable Option?

Is it possible to have a paper system in the age of computers? Yes, and I would be remiss if I did not acknowledge certain circumstances that make a computer system impractical. The three common circumstances are: (1) a new art firm operating as a home based sole proprietorship or a *by appointment only* gallery, (2) a successful small but high-end gallery with few personnel and requiring relatively few invoices, and (3) a truly computer-phobic small art firm owner who may not be sufficiently well capitalized to acquire outside expertise.

In the first circumstance, unless you happen to be particularly comfortable with computers, you will find that getting organized immediately, via a paper system, will be preferable. In addition, the extra expense of a computer and software may not be justified for a small start-up operation particularly if the initial volume of prospects and actual sales is minimal. Once you establish a collector base, and have worked out the details of your prospecting and follow up system, inventory control measures, etc. — you should reconsider using a computer.

The second circumstance is predicated upon the fact that a small number of high-end sales will sustain a gallery. Using a computer for one sale every two weeks is not essential. This is particularly true if the number of prospects is small and the physical inventory is minimal.

The third circumstance is a question relating to your particular state of mind. If you are computer phobic and can not hire experts to provide initial advice and a dedicated employee operate the system computer person, then computerizing could turn your nightmare into reality. I do not mean to frighten those of you who are merely inexperienced. If you follow my guidelines you will be fine. Rather, I am talking to those of you who know yourselves well enough to know that no amount of training, cajoling, and/or hand-holding will turn you fear of computers into love.

Once you sit at a terminal and retrieve a client file in 5 seconds as opposed to thumbing through a massive three-ring binder you will appreciate the value of computerized record keeping. Running 1500 mailing labels in a script type face in minutes instead of hours of typing will remind you of the wonders of computers.

Regardless of when you start your quest toward computerizing, remember to talk to a professional or a gallery owner or manager who has previously been down your path. You can find experts and gallery specific software advertised in art trade periodicals such as *Art Business News* and *DECOR*. The annual *DECOR Source Listings Issue* lists gallery software vendors under the category Special Services. The annual *Art Business News*

Buyer's Guide lists software vendors under the category Special Services & Products. You will also find experts lecturing and gallery specific software being demonstrated at major art trade expositions.

CHAPTER FIVE

THE PHYSICAL SET-UP OF YOUR GALLERY

The perfect universal gallery floor plan does not exist. Readers of trade publications such as *DECOR* and *Art Business News* are exposed a myriad of successful gallery designs and space utilizations. The factors involved in answering questions relating to how many square feet, street level or upper floor location, shopping mall location versus downtown or free standing are so specific to your start-up budget, the nature of the art you offer, the geographic area and its demographics, that it would be misleading to attempt to offer generalized answers to those questions.

Nevertheless whether you are in charge of a retail space or operate from your home the operations that take place on the selling floor, in the dimmer or closing room, and back office are substantially similar.

The following is a description of the tasks and the essential equipment for completion of those tasks. The term *floor* is used as shorthand for *selling floor*. The term *dimmer room* has largely replaced the term *closing room* as the description of the designated area for displaying the work of art the client prefers and the closing of the sale.

> **A. On-The-Floor**: As space allows, desks
> should be provided with suitable space to
> store organizers, sales paraphernalia (e.g.,
> brochures, stationery, sales books, credit
> applications, shipping forms, credit card
> imprinters, etc.) for each art professional.
> In most cases, one desk will be shared by
> two art professionals (at separate times).
> In addition, each art professional will
> have their own designated file cabinet and
> desk drawer. Such a set-up will allow
> good use of time on-the-floor when traffic
> is slow or nonexistent. The type of

collector development activity that is best performed on-the-floor between client contacts include:

1. letter signing

2. envelope stuffing

3. setting up appointments by phone

4. confirming appointments by phone

5. thank you note writing

6. goal setting

7. calendar reviewing

8. things-to-do list writing

These activities should be supervised by the gallery director, sales manger or the owner to ensure:

1. No walk-in clients are inadvertently ignored.

2. The type of collector development activity performed fits into the *easily interrupted category* such as examples given above.

3. No intense phone sales presentations are carried out while *on-the-floor*. Any exceptions must be authorized by the gallery director, sales manager or the owner. This activity is best performed

off-the-floor where little or no interruptions occur. This preserves the effectiveness of your sales presentation with each client while giving the overall best impression to both prior buyers (on-the-phone) and walk-in prospects (on-the-floor).

4. An appropriate *up system* is in place and is understood and followed by the sales staff.

The use of an organizer should be required while art professionals work with walk-in clients when setting up appointments. This provides a sense of personalized attention, high professional standards, and the faith that *any commitment* the art professional makes (home delivery, phone follow-up, invitations to be mailed, etc.) will actually occur.

B. Off-the-floor:

1. Collector Development Room: As space permits, your showroom should have a room dedicated to collector development activities. This room should be equipped with desks, sales materials, file drawers, etc. (As on-the-floor, but with more space allocated for work areas.) In addition, there should be comfortable ventilation, bright and

cheerful ambience (color, flowers, plants, classical or new wave music, etc.), easy access to a rest room, coffee pot, and refrigerator stocked with refreshments.

2. At-Home Office: As space permits, each art professional should dedicate space in their home to allow efficient collector development activities. A desk with a file cabinet is preferred to organize the necessary records, sales paraphernalia, and art/product literature.

3. At Client Location: As opportunity arises, you should consummate business at your clients office, home or other off-site locations. The business you will conclude may involve:

 a. Obtaining referrals.

 b. Delivering and hanging acquired artwork.

 c. Delivering and hanging potential art acquisitions.

d. Setting up a home exhibition and reception.

e. Setting up an office exhibition and reception.

f. Setting up a remote location exhibition and reception (at a botanical garden, art academy, etc.) with the clients backing and involvement.

g. Executing any home/office/ or remote exhibition and reception.

The use of a time organizer should be required for all the same reasons it is required with walk-in clients — only its importance is magnified. Any commitment you make as follow-up should be lived up to. Anytime a client allows you into their home or office, or exchanges money for artwork, he or she is deserving of your utmost respect and attention. Their relationship is **first** with you as an art sales professional and **second with the gallery**.

C. **On-the Phone**: The phone can be used at almost any time including on-the-floor and off-the-floor (as well as places in-between!) Cellular phones permit the efficient use of commuting time whether it

be by automobile, bus or train. An organizer should be used at all times when you are making commitments to clients and prospects. This avoids any chance of inadvertently forgetting one.

Moreover, attention must be paid to how you can most efficiently execute the client service activities. The manager must impress upon each art professional the idea that efficient execution relies upon the following:

1. Making most of the intense phone sales presentations during scheduled collector development time while in the collector development room.

2. Using the collector development room time to organize easily interrupted tasks prior to completing them on-the-floor.

3. Using the phone while on-the-floor for primarily setting up and confirming appointments.

4. Having their organizer, sales paraphernalia, art/product literature readily available (which is why, of course, the

collector development room is
most efficient).

Lastly, whenever an art professional is on the phone with a client or prospect they must always follow established business phone etiquette.

1. Always introduce themselves
 and identify the gallery
 immediately.

2. Ask if this would be a
 convenient time to talk. If yes,
 continue — if no, ask when
 would be a better time.

3. Ask whether or not the client
 has received the letter or
 invitation prior to any intense
 presentation.

Finally, the main reasons the phone is used so extensively are:

1. It is the most affordable and
 efficient way to follow-up on
 a prospect (for a new sale) or
 a client (for repeat business).

2. Studies have shown 60% of all
 sales are completed on the
 sixth contact. Thus, phone
 follow-up is an essential
 ingredient in your sales
 success.

Private dealers who primarily work at their clients offices and homes need only be concerned with having a home office that contains the essentials for the back office. The selling floor is the client's space.

Private dealers who do sell from their homes should have an uncluttered space set aside for showing and closing. The back bedroom on the second floor that is your makeshift office is not an appropriate sales space.

Scheduling Time on the Floor

As a general rule, the gallery director, sales manager or owner will tend to schedule more on-the-floor time for less experienced art professionals. Less on-the-floor time will be scheduled for very experienced art professionals. The reason for this is two-fold:

1. New art professionals **don't** have a large collector base of prior buyers to achieve fruitful results in the collector development room.

2. Experienced art professionals **do** have significant contacts who demand collector development attention. The can therefore make fruitful sales results in the collector development room. Keep in mind, a prior buyer is *six times* more likely to buy from you than cold traffic.

Major Mail/Phone Campaigns vs. Minor Campaigns

As a general rule, the gallery director, sales manger or owner should schedule more off-the-floor time for major mail/phone campaigns — less off-the-floor time for minor ones.

CHAPTER SIX

PLANNING AND EXECUTING PROFITABLE EXHIBITIONS

Successful art firms accord the planning and execution of exhibitions and/or promotions a high priority. For these firms, the goal is to efficiently expend predetermined resources with the near term goal of creating immediate sales and the long term goal of laying a foundation for future sales.

The keys to having profitable exhibitions and promotions involve creating a niche for each artist, planning events well in advance, arranging a meaningful charitable connection, creating an imaginative exhibition theme and its supporting props, designing a creative public relations campaign, designing a direct mail piece, and designing an exhibition invitation.

The bottom line is that the old tired art exhibit with champagne and finger food is not going to get your clientele excited about attending. Rather, it will be *the trip to Brazil* with Brazilian music, dancers, and food that features an artist whose mission in life is to immortalize the vanishing rain forests of South America. The art acquisition tie-in is that every buyer *saves a tree*.

Your imagination and budget need be the only limitations. While higher end art professionals can perhaps see the possibilities a little clearer than those with lower price points, I wish to inspire both ends of the price point spectrum. I have attended impressive functions put on by independent art dealers working from their homes. Who says you can't rent the most luxurious ballroom in the city, trees or whatever else you may need to pull off a large event. Or what about those friends and associates from your favorite charity that might love to host your function in their ocean front home in Malibu!

And let's not forget the effectiveness of small, intimate affairs which can still take advantage of the key attractions. A small, private reception with

the same Brazilian theme and its other components (just on a smaller scale) can be just as effective and will work for even the lower price points.

It is the role of the gallery director, sales manager, or owner to manage the planning and execution of exhibitions, promotions, and events. The operative word is *manage*. Don't attempt to do everything yourself.

Involve your art professionals and administrative staff in the planning and execution. If you have no staff hire professionals to assist you in planning, the design of mailing pieces and invitations, and the mailing itself.

The following materials relate to common elements in any exhibition, promotion or event.

Effective Design of Your Exhibition Invitations

The actual design of the invitation is limited only by the imagination of the designer and the budget. There are however eight categories of essential information that must appear on the invitation. At least twice a year I receive an elegant invitation that omits one or more categories of essential information.

Each invitation should contain:

1. the name of the gallery

2. the address of the gallery including the city

3. the opening date and time *and* the days/hours the gallery is open

4. the name of the artist

5. the medium

6. the name of the exhibition (if there is one)

7. the opening and closing dates

8. a phone number for the gallery or person from whom information can be obtained.

In addition you should add a copyright notice to protect the rights of the artist in the art which is reproduced on the announcement.

A significant number of those who receive the invitation may choose to skip the opening but will be interested in the exhibition. Be certain to include the dates for the run of the show and your gallery hours even if they are on the verso of the invitation.

The Invitation Is An Event

If you wish to continually appeal to *The New Market* — those who fit the demographics of art buyers of today — then your exhibitions must become events. The invitation should trumpet a *not to be missed occasion*.

Highlight an experience and embellish a theme! Why should I take time out of my busy schedule to attend an exhibition of art and sip white wine when I can attend an opening down the street and be dazzled by freshly imported exotic flowers, music, and dance. Plus, by attending this event, if I see something I like, I get an opportunity to help preserve our environment. If I had a choice, I would pick the second event. Your invitation should help set the mood of the experience you wish to create.

Schedule an event within an event! This will allow you an opportunity to address the entire group after most of your guests arrive. It is at this time you wish to romanticize the artist (and let him/her speak if that are marketing oriented), unveil the easy access art tie in with your charity, and announce the event's goal (e.g. *With your help tonight, we can save 10,000 acres of redwood forest that is otherwise doomed to disappear....*), show slides or other visuals to illustrate your mission.

This event within an event, while the heart of the show, must be carefully choreographed to be fast paced (otherwise your guests will

tune-out) and should last for no more than fifteen minutes. It should be theatre, not a boring lecture.

If effective, the event within an event will become a positive feature of your openings. Your collectors will look forward to being present at the event within the event. It should always be highlighted on your invitation.

Romanticize the artist! This should be done on the invitation in two ways: (1) flamboyant copy that makes the artist an irresistible person of celebrity status, and (2) an exciting visual representation of the artwork.

Sometimes an artist will resist the creation of a *persona* you wish to market and promote. While not every artist can be swayed, I have found that those craving economic success usually agree to this and enjoy it. The payoff to the artist is reflected in the proceeds from of more art sales and exhibition attendees.

I am reminded of one of my favorite artists here in the islands, Caroline Young. When I first met Caroline she defined herself as an artist in rather vague terms. She had both Japanese and Chinese roots and at first her artwork was a mélange. She did well but it was not until a Wholesale Marketing Manager — Yolanda Kelly, helped her to decide upon a Chinese princess *persona*, did she come alive artistically.

With that focus, *Caroline's public persona* was dressed in elaborate silk Chinese robes. Her hair was pulled back in an elegant chignon. She looked the epitome of Chinese royalty. Now her paintings took on the culturally rich symbolism of ancient Chinese legends. Her exhibitions had a Chinese flavor filled with rituals and decorations that transported collectors to China.

Artists who have goals other than commercial success may scoff at using theatre. But the financial success of Caroline Young and her dealers convinces me that theatre works.

The following page illustrates the transformation of a typical exhibition invitation into a more interesting invitation.

CREATING A MORE EFFECTIVE SHOW INVITATION

If you wish to continuously appeal to *The New Market*, your shows must become events. The invitation, in turn, should commemorate this special occasion.

- Highlight an *Experience*
- Embellish a *Theme*
- Schedule an Event within the Event
 (e.g. - unveiling, lecture, slide show, philanthropic activity, etc.)
- *Romanticize* the Artist

Embedded within this schema is the importance of creating, Planning, and "Pulling off" such an event.

A TYPICAL INVITATION

We cordially invite you to a special reception in honor of world renowned artist

J. MONET

FRIDAY, FEBRUARY 3, 199X 7 to 10pm

Studio International
825 Main Street, Anytown, USA (808) 239-4280
Validated Parking

A BETTER INVITATION

When was the last time you were in Paris?

Join Studio International and Jacques Monet - renowned connoisseur de femme et vin, and artiste extraordinaire - in our magnifique art show...

Springtime In Paris

A delightfully romantic tour in paintings, prints, and posters of the irresistible ambience of
Le Jardins des Paris - The Gardens of Paris

Friday, February 3rd, Unveiling at 6pm with libations and Music to follow.

Studio International● 825 Main Street● Anytown, USA ● 808 239-4280

Note that the verso of the invitation may be used to set forth information relating the run of the show and gallery hours.

Small, Intimate Home Art Parties and Private Receptions

Planning a small, intimate art event is a bit like planning any art marketing event. It's just on a smaller scale. For many independent art dealers with no showrooms (other than the display collection in their homes) this is a good way to facilitate meeting prospects. I know numerous success stories of art dealers who make frequent use of this exhibition format.

In addition, it is an excellent way for larger art firms to work with clients. In particular, a gallery owner will note their top producing art consultants' success with certain key clients. They then encourage scheduling a small private reception or home party format for the top tier collectors. This will further cement the relationship between the collector and the art firm. The collector will see this as preferential V.I.P. treatment — as indeed it is.

In general, you will wish to schedule the smaller event in between the larger gallery exhibitions. This will accomplish two important things: (1) you will stave off burn-out, and (2) you will maintain a steadier income stream. You will accomplish these goals while strengthening the critical ties with your important collectors.

As you plan your small events, keep in mind that your main focus should typically revolve around selling artwork that very evening. I say, typically, because there will be instances where you will have a well qualified prospect over for dinner, for example, and your primary focus will be to build a strong rapport before getting into a closing situation.

The following guidelines are directed toward assisting you in creating successful small art events. The goal of these events is for you and your staff to be able to close sales with clientele with pre-qualified prospects. At a successful event, your art consultants will close sales. I have chosen the small independent art dealer scenario to exemplify the guidelines.

Planning the Home Art Event

1. Schedule creative/brainstorming time with at least one other person. This may be your best friend, spouse, young adult child, or business associate. This person should care about you and your art business and be creative. Let the ideas fly!

2. Write down all of the ideas.

3. If it is your first experience with at home events, plan no more than two home events the first month. Space them two weeks apart to allow ample time for restructuring your format. Changes are inevitable (your display set-up, theme selected, decorations, etc.) but the important thing is to plan the time in between the first two events to dissect them with ruthless candor. Dissection will assist you in creating a better home event format.

4. Once you have the experience with this type of marketing, establish a plan for the upcoming year. Because 60% to 65% of the art buying public are deliberative thinkers and loyalists, you would do well to incorporate annual events even at this low-keyed level. Example are: (a) an annual Christmas [Holiday Season] Party (scheduled for late November or early December) with a silent auction offering framed decorative art suitable for gifts, (b) an annual joint fund-raiser function, (c) an annual authentic French meal served with imported wine and the latest art from Paris (or featuring artists inspired by the great Parisian impressionists).

5. With your home art event schedule in place, review your client list (prior buyers, prospects, and referrals) to plan your phone time at least three weeks ahead of each event. This is especially true if your clients have young children, travel a great deal, indulge in lengthy vacations or are active in community events. As you progress through your marketing plan planting seeds throughout the months of the next *this* or your first annual *that*, your key clients will begin to plan their vacations and other activities around your events.

6. Create a letter or invitation to send to selected clients alerting them of the up-coming event. Spotlight the art! A single featured multiple work (e.g. a limited edition sculpture or, graphic) or a suite of 3 to 6 originals.

7. Before you call, review your attendance and sales goals for each event. Remember, a small event can be enormously successful with one guest as long as the guest is, in fact, a qualified collector. Block off time on your calendar to call all of your potential attendees. Two hours every other day for a five day period will allow you to pace yourself and tends to yield better results than ten hours of phoning in one day.

8. Design the layout of your art display, decorations, signage, and other props. Create a warm yet visually stimulating environment. Put some imagination into your backdrop. If you wish to transport your clients to Paris rent small cafe style tables and chairs with red and white checkered

table cloths. Set a candle burning in an old wine bottle. You have created a Parisian backdrop for the art!

If you are under the impression that sophisticated individuals are not entertained by theme parties you should attend four or five of the charitable fund raising events in New York, San Francisco and Chicago. They are theme galas. Minimum contributions range from $250 to $1,000 per person.

9. Relax, take a few deep breathes and visualize yourself (a) strengthening rapport, (b) getting everyone's attention with your art buying special announcements, (c) enjoying the interchange, (d) comfortably sharing with your small handful of guests thoughts about the art, and last — but not least — closing sales.

At the Event

1. Greet everyone. Make it special. In Hawaii, we give people leis — in Michigan, a single red rose in the middle of winter is a delightful treat. If there are more than five couples, have everyone go through the ritual of signing your guest sheet. This helps you stay on top of any address and phone number changes. Routinely encourage your clients to bring a friend. Offer a discreetly awarded incentive/gift for suggesting a friend who attends. The guest sheet sign-in procedure is a straightforward way of obtaining the correct spelling of the names, complete addresses and phone numbers of new prospects. Be certain that

the guest sheet suggests that names and addresses be printed.

2. Once all expected guests have arrived and after a suitable social period, convene your attendees for your special announcements. If you are unaccustomed to public speaking, make yourself as comfortable as possible — arrange pillows on the floor and have everyone seated or arrange the chairs in a tight area so you won't have to project your voice. A soft voice and a small area makes for a more informal and relaxed ambience.

3. Your announcements should be kept brief. Ten to fifteen minutes is a good guideline followed perhaps by an even briefer question and answer period. The main purpose of this is to have your group coalesce toward art appreciation, the support of a featured cause, and art acquisition. Review the following sample opening statement and announcements:

Sample Opening Statement And Announcements

My husband Bill and I would like to welcome you to our home. Our home is also the showcase for our new art firm which have named Fine Art Treasures. We hope our name helps you to think of us whenever you dream of acquiring a rare or unique art masterpiece.

Our theme tonight, as you all know, is The Third Dimension. We are featuring the world renowned sculptors, Frederick Hart, Bruce Turnbull, Pascal, and Erte. Pascal and Erte each have a unique line of

wearable sculpture that we will be focusing on this evening. How many of you are familiar with any of these artists? (Dialogue) Fantastic! Do you see anything displayed that is particularly striking? (Dialogue) Great!

One of the nice things about working with us is that whenever you bring these fine art sculptures into your life you indulge yourself while helping to save the environment. That's right! A percentage of the proceeds from all acquisitions tonight will go to benefit our state's reforestation project as part of Global Ecology.

In keeping with this theme, we are featuring, (title of piece), by Pascal which depicts an exquisite glass sculpture of a lovely bird with jewel embellishments. We feel that a bird makes a fitting tribute to the importance of trees because birds make their homes in our forests. Don't you feel a bird would act as a poignant reminder of our mission to reforest our state? Without adequate numbers of trees, the voices of many song birds would be stilled. (Title of the piece) is available on an exclusive basis through our firm. You will not find it in any gallery or jewelry store. I am proud to offer this small limited edition wearable sculpture on a pre-publication basis for only $750.

(Note: As you make these last two statements, accompany your words with a flourish of an unveiling.)

At this time I would like to introduce Joanne Bixby. She currently heads our state's reforestation project and has graciously agreed to join us tonight. Let's make her feel welcome (start the applause). Joanne will say a few words about the project and show us a five minute

video. After the tape we will have a brief question and answer period, followed by refreshments and music.

Lastly, I've asked my niece, Charlene who is studying art history at the university to assist us tonight in filling out your art acquisition documentation. Thank you all for coming... Please enjoy the evening!

4. Follow your own suggestion — Enjoy your art home event! Your ease and comfort at the event will help everyone else relax and enjoy it all the more.

Post Home Art Event

1. Mail a personal thank you note to each person who attended and send a special thank you (e.g. flowers) to all those who acquired art and any special guests who attended.

2. Call each person that you deem truly qualified. A truly qualified prospect is someone who has the disposable income to spend and the motivation to acquire your art now or in the near future. Tell procrastinators or deliberative thinkers that the deadline (i.e. whereby a percentage is donated to the charity and/or the special promotional pricing) has been extended based on their *need to think about it*. The extension should be only one to two weeks. In this interim, you will progress to a sale via phone calls and/or face-to-face appointments in the prospect's home or office. You will be pleasantly surprised how much of a difference this kind of follow-up can make. For

those of you accustomed to making little or no sales at such events, you can expect to make more than enough to justify the event. For those of you whose sales skills are more sharply tuned and/or already have a strong collector base, it can easily double of triple your sales results.

3. Meet with your brainstorming partner and dissect the event. Make adjustments and move to the next project.

4. Celebrate your results. This is vitally important for the small business owner particularly if you are one-person operation using temporary personnel or volunteers. Engage all your assistants in this celebration — a luncheon with a cake, dinner and drinks at the local pub or whatever suits the fancy of your team. You will be amazed at how often people will volunteer to help a relative or friend who provides stimulating part-time employment (even when it's on a commission-only basis). You must, however, remember to demonstrate your appreciation. As your business grows, some of these temporary assistants will want to join you full time.

Now, let's examine a few ideas for home art parties that you may find stimulating as you discuss possibilities with your brainstorming partner. Many, if not all, of the examples that follow can be done on either a small scale or on a grand level.

Joint Fund Raising Projects:

Audubon Society

House the Homeless

The Heart Association

Your local symphony or dance group

Your local hospital

Food And Art Parties:

Parisian Food & Impressionist Art

Italian Food & Mediterranean Art

Yugoslavian (Croatian) Food & Art

Chinese Food & Art

Native-American Food & Art

Renaissance Period Food & Contemporary Art

Entertainment & Art:

Flute and Piano with Classical Art

Guitar with Spanish or Southwestern Art

Japanese Tea Ceremony with Japanese Art

Art Education:

Art preservation seminar

The Impressionist Revival - First Monet now Americo Makk

The Ethnic Art Boom - Why & How To Make The Most of It

Making a Serigraph (demonstration at artist's studio)

The Art of Collecting Art

Commemorative Events:

Historical tie-ins with art reminiscent of the period

African-American History Week and art

Your yacht club's 30th anniversary and marine art

Planning And Executing Large Art Exhibitions And Events

Planning and executing a large art exhibition is done in a very similar fashion as the small event. The major differences have to do with (a) scale (room size, amount of art displayed, logistics of writing up orders, etc), (b) publicity, and (3) working with a sales team (typically full or part-time employees).

I have chosen a medium sized gallery scenario for the following guidelines. I have assumed that the gallery owner has a director and a staff of art consultants. The actual event may be staged in the gallery, hotel ballroom, private mansion, or other suitable space.

Exhibit Planning

1. Schedule creative/brainstorming time with your key people.

2. Brainstorm ideas, themes, promotions, and other activities related to the exhibit

3. Record your ideas.

4. Plan no more than four major exhibitions or events per year, but do plan out as far as twelve to eighteen months. After you are experienced,

major exhibitions or events may scheduled every other month work and out quite well. Greater frequency can lead to the burn-out of your sales team. So often, less is more for established art firms. One client of mine conducted so many major events it became impossible for the sales staff to take any time off. Needless to say, the owner had to slow down the pace which not so coincidentally created greater sales results and much higher employee morale.

5. Call/write news media, artists, philanthropic sources, and celebrities twelve to eighteen months in advance for their commitments. My clients and I have found that high powered individuals, celebrities, and heads of the major charities all are far more likely to appear at your function if asked a year or more in advance.

6. Begin the process of igniting your sales team (even small teams of your commission only part-timers) with bits of information concerning the event. You can start nine to twelve months in advance and stage the announcements as part of your regularly scheduled sales meetings.

7. Have the gallery director meet with each art consultant individually to review their respective client lists (prior buyers, prospects, and referrals) and help plan their phone time at least ninety days in advance. As this kind of prior-buyer centered thinking becomes routine, each art consultant will have time blocked off every week to call and write clients about something whether it is a direct mail promotion, small event, or large

event. One of the key things that this meeting will do is simply assist the art consultant with the necessary focus. It also allows management to stay on top of what each individual sales person is accomplishing to help make the event as successful as possible. This makes the task of coordinating the logistical considerations (e.g. food, drink, gifts, hand-outs, floor lay-out for good traffic flow, etc.) more straightforward. In addition, by alerting clients well in advance, you get them to anticipate and plan for your events. In fact, an annual cycle of mega events for your top four artists will engender loyal sojourns by your key collectors.

8. Create a letter to send to all prior buyers alerting them of the up-coming mega-event. The letter should spotlight a single featured multiple work of art (e.g. limited edition sculpture or graphic) or a suite of 3 to 6 originals. Establish a mandatory phone follow-up schedule for yourself and the entire sales team to call all who are sent this letter.

9. Have the final invitation available at least one month in advance. Time your press releases (and advertising if applicable) to fit the editorial lead time and advertising closing dates of key magazines and newspapers.

10. Send the invitations out — time them to arrive one week in advance.

11. Lay-out your gallery's metamorphosis (or rented ballroom, or your client's mansion, etc). If it is supposed to look like Paris put some imagination and bucks into creating Paris.

12. Have the gallery director meet individually with your entire sales team in order to ascertain the number of holds and pre-exhibition sales generated from their mail/phone work. Announce the overall results at the sales meeting immediately prior to the show.

At The Art Show

1. Have a receiving line to facilitate greeting everyone. If most of the attendees are not prior buyers (as might be the case for a new art firm), then have each person sign a guest book. Columns or lines should be clearly designated for their name, address, and phone numbers. Here's a tip that works well — as the people approach the greeting area, say hello along with — *Thank you so much for joining us this evening. How did you hear about us? (Dialogue) Well, as you can see we have quite an evening planned for you (as music the intoxicating smells, sights, and sounds entice them). If you would like to receive an invitation to our next gala, please sign our guest book. Oh, and I will need your phone number, as we confirm our guests' attendance in order to finalize details with the caterer.*

I can not over emphasize the importance of this ritual — even if you have to set up six sets of greeters with guest books to accommodate a large crowd. In fact, the larger the crowd, the more important this becomes because there is nothing worse than disappointing hundreds of potential collectors with less than adequate follow-up. Particularly if you live in a town where bad news travels fast (and who doesn't). The bad news would sound a little like this — *Did you go to that bash down at the new gallery downtown? ... well, one of the sales people*

told me he would be getting back to me but never did! Frankly, they seemed so disorganized. While we would hope your salespeople are extremely conscientious, it is simply an impossible task for them to systematically obtain the requisite data from every person in the room. As the gallery owner, it is your responsibility to them (as well as yourself and the artists) to make their follow-up as straightforward as possible.

2. Have a microphone for the announcer (even if there is a small group of twenty and especially if the group is larger than 25) — this makes everything more dramatic. A raised platform is a must for large crowds. The announcer who orchestrates the short program should be an excellent public speaker and speak with flair. The short program may consist of an unveiling, lecture, slide show, or demonstration — your imagination is the only limit.

3. The announcer should announce over the microphone the key promotion of the show. In might sound a little like this — *We are featuring (artist's name)'s newest serigraph entitled, (title of piece). When I unveil it I think you will agree that its composition and colors will transport you to another era when our institutions were not just valued — but revered. And now (title of piece) gives us a second chance to demonstrate a sense of pride and commitment to one of our own great institutions — our own renowned but under funded Art Academy. A portion of the proceeds from every serigraph you acquire tonight, will be donated to the Art Academy. Your attendance tonight tells me you are a lover of the arts — our goal along with that of the artist is to donate (dollar amount) this year to the Art Academy so their (Name of Program) can continue. Ladies and gentlemen, tonight we*

have a chance to make real progress toward that goal. Collectively, we can make a difference.

4. The key promotion should be at an easily accessible price point. You want volume. You want to create your own version of a buying frenzy. There is something that sweeps people up when they see many of their colleagues/peers participating in something that has all the earmarks of good value and a worthy cause. It also makes higher end sales easier to close.

5. Enjoy your mega-celebration!

Post-Show

1. Have your gallery director meet with each of your art consultants to set-up a phone follow-up schedule so that all who attended, expressed some interest, and are deemed qualified are called within two to six days after the event. As mentioned in the guidelines for planning and executing small events, this activity can translate into enormous sales results — easily doubling or tripling what you have ever previously experienced. When you call, it is important to alert the attendees that the promotion and opportunity to donate has been extended in response to all those requiring time to think.

2. Celebrate your results. The celebration should correlate with the results of the event (sales/profit/charitable contributions). This may range from special refreshments at the next sales meeting to a luncheon or an elegant dinner for your art consultants. Thank your staff for a job well done.

3. Announce the next mega-event.

art dealers (and their sales teams) do many
ove guidelines — but I have repeatedly
areas overlooked or misunderstood. More
tion is paid to:

romotion(s):

a charitable connection.

the easily accessible price points
ve volume.

ahead sufficiently to obtain
magazine publicity and public
e for your charitable connection.
for inch, publicity and public
ge have five times the market
paid advertisement. Moreover, a
be many times the size of one of
your ads.

- Failure to have a sincere charitable connection.
 Yes, we are speaking of clever marketing tools —
 but the kind of people you wish to attract as your
 collectors, are the very ones who will see through
 insincere gimmicks. Search deep into your heart,
 if necessary, and find a cause that you and your
 team can truly get behind.

B. Letters and Phone Contacts with Prior Buyers

- Failure to send a promotional letter well in
 advance.

- Failure to call (or insufficient number of persons
 called) to obtain holds and pre-exhibition sales.

C. The Exhibition As An Event

- Failure to be imaginative.

- Failure to plan well in advance.

- Failure to line-up *well known* persons in conjunction with your charitable connection.

Watch out for those pitfalls. If you avoid them you can look forward to more successful exhibitions. Moreover, you and your team will experience the joy of making a major difference in our society as a whole, your own community and its treasured institutions. It is a good feeling!

Designing Your Next Promotion — A Road Map

How do you design a promotion to maximize the chances of success? Most people in the art industry have good instincts, developed over years of experience, but many don't take the time to develop a set of criteria — a road map to success.

A road map should be reduced to writing. That a written map is required is never more apparent than when you go on an extended vacation and the person left in charge fails to do the obvious.

What kind of road map should you draw to aid the person in charge so that the promotions designed and executed in your absence are just as profitable as those created by someone with experience and good instincts?

Let's examine a road map and make it a useful guide for yourself whether you are a one person operation operating from your home or a gallery owner with a staff.

First, allow me to define what I mean by a promotion — it is an event, show, or direct mail/phone campaign featuring artwork with advantageous limited time pricing with compelling yet intelligent reasons for the potential collector to decide promptly. Such a promotion is set in place primarily to

stimulate higher sales as compared to just relying on walk in sales. With this as our working definition, let's walk through the elements of the road map.

Selection

The selection of the artist and specific artwork is critical. Select the artist with the strongest collector base and choose a piece that's similar to other successfully marketed artwork. This combination will result in the most gross receipts. It's amazing how many art dealers opt to conduct promotions around art that doesn't sell well, dead inventory or an artist whose work is difficult to market.

Recognize that getting rid of dead inventory requires a special twist. Try hosting an art auction or pairing the less marketable piece with a desirable work at a substantial saving!

Note also that launching a yet-to-be discovered artist is an entirely different story that must be planned and executed while you sell more marketable artwork. Once a yet-to-be discovered artist is groomed and test marketed, you will have developed a small but strong base of initial collectors at relatively low price points. You must build from such a beginning.

Check Inventory

Now that you have selected your most marketable artist and his/her hottest work, it's time to check your inventory. Do you have the quantities on hand to allow prompt delivery in the event you get the number of orders you were planning (hoping) for?

If this is a pre-publication offer, do you have a good handle on when the artwork will, in fact, be deliverable? And even then, add another six to eight weeks to any commitments you offer your clients — especially those provided in writing.

Determine Your Projected Return

Take a look at the number of your prior buyers and motivated prospects (people who you have qualified recently but who have yet to buy). If you have 50 prior buyers/prospects with a $2500 offer, you can project a 2% to 10% return (i.e. $2500 to $12,500+ in gross receipts). Recognize the variables which will affect this formula — number of prior buyers vs. prospects that are called — the general state of your local economy — and the telemarketing skill level of those making the calls.

The variable that you must take *full responsibility* for will have the greatest impact on your sales results — the more prior buyers called (vs. prospects), the greater your results will be. By projecting your results in this manner, you can back into your justified expenses such as added incentives for your sales team and your collectors, as well as the costs of the event and the printing and mailing your collateral material.

Ask yourself, *Is this worth all the time, energy, and resources required to pull this off in a first class manner?* Most art dealers prefer to profit from their promotions most of the time. On those occasions when profit is not the primary motive, it's still valuable to project your return so you can balance non-for-profit projects with your profitable ones. That is important for the sake of your sales team, particularly those who work on commission.

A Few More Checks

Check the 3 C's: Color, Composition, and Cost. Does the artwork have similar colors and composition of other historically successful promotional pieces. Does it cost about the same on a retail basis?

As long as you are clear that your promotion is designed to make money versus test marketing then this concept makes a lot of sense. When you do test market, do it on a small scale in conjunction with one of your marketable artists. For example, exhibit the test art at a exhibition alongside the historically successful art. These nose-to-nose reactions can give you the

insights needed to pursue new directions (while still capitalizing on the foundation already built). All successful companies test market. While your instincts may be great, there really is no need to gamble with so many of your resources — not the least of which is the morale of your sales team.

Lastly, check the price points. If your records indicate the average invoice amount for your 500 prior buyers is $3,500 then a promotion offered at $2500 is easily accessible to most of your collectors.

Design Incentives

Design incentives for your buyers to buy now and your sellers to sell now! The additional sales will more than compensate for the extra you share with your sales team and collectors. I encourage my clients to make the incentives as lucrative as possible — then the sellers will call and the buyers will buy. The more calls made, the more sales made. I discuss this in more depth in Chapter Ten, *As Your Art Firm Grows.*

The Kick-Off

Never underestimate the power of the unveiling at a sales meeting. In fact, the more exciting you make the kick-off (with all other variables in place), the more results you can expect. For a particularly important promotion, you may wish to change the site from the gallery to a seaside (lakeside, penthouse, etc.) restaurant or a historic location that ties into the promotion — use your imagination!

Award and Celebrate

This is perhaps the most important variable of all, and one quite often overlooked. When the team does a fantastic job, let them know in a fantastic way. Celebrate generously so everyone will be upbeat and inspired to make a success out of your imminent promotion.

In summary, now that we have walked through our road map, I feel confident you can construct your own version. To facilitate this endeavor, you may wish to make use of the following work sheet.

Design Your Next Promotion

Worksheet/Checklist

1. Select highly marketable artist: _____

2. Artist's theme and message: _____

3. Inventory available (unless pre-publication): _____

4. What would 2% return on your prior buyers be? _____

5. What would 10% return on your prior buyers be? _____

6. What is the budgeted cost of this promotion? _____

7. Is this a good pay-off? 2% return less cost = _____

8. Is this a good pay-off? 10% return less cost = _____

9. Check the 3 C's and historical success — OK? _____

10. Is the featured artwork plus or minus 20% of your average invoice amount? _____

11. What would be a good sales incentive for your buyers?

12. What would be a good sales incentive for your sales team?

Once you have made use of the promotion Worksheet there are a few more things you will want to ask yourself about any promotion you conduct involving 1000 or fewer mail outs:

- Does the featured promotion have a *hook*, expiration date, as well as a visual? The *hook* is the compelling, sincere and intelligent reason for the collector to make a timely decision.

- Will each person be called?

- Has each person provided permission for the recontact prior the call?

- Has an alternative work of art been ascertained? In the event the featured piece is totally off the mark, it is valuable to have yet another mini-promotion already designed to keep the ball rolling with as many collectors as possible, Sometimes the shift is toward and entirely personalized work of art — the smaller the group you are prospecting, the more often this will be the case.

- Regardless of whether a sale was consummated, will the person be asked permission for you to recontact (for as specific a reason as possible) yet again in the near future.

- Has each person been asked for referrals?

If all of the variables discussed are in place, you will have the best chance of succeeding even in a tight economy. Recognize, the variables discussed are all within your control. Think of it! Earn a reasonable to outstanding income even when your competition is crying the blues because you have tightened up every aspect of conducting a successful promotion. Yes, success is sweet!

CHAPTER SEVEN

EXHIBITIONS & EXHIBITION PROTOCOL

1. Guarantee Yourself a Successful Exhibition

a. Each art professional should meet with the gallery director or owner individually to review their Exhibition Organizer form (a compiled list of potential attendees who are prior buyers, prospects, and referrals). Meet first at least 90 days in advance of the exhibition.

Yes, even if you are a resort gallery!. Some of your best clients will plan their next visit around your exhibition. In fact, an annual cycle of exhibitions will engender loyal annual vacation trips by your best collectors.

b. Create a pre-exhibition letter to send to all those on this list. The letter should alert potential attendees of the upcoming event and spotlight a featured multiple work (e.g. limited edition sculpture or graphic) or a suite of 3 to 6 originals. The letter should be received 30 to 60 days ahead of the event.

c. Each art professional should call everyone on their respective lists to confirm attendance and/or possible art acquisition (most likely the featured artwork) at least 20 to 40 days in advance. In most cases the initial phone call should be made shortly after the client has received the pre-exhibition letter — a second phone call should follow — that allows them time to think about it — and a final call one week ahead to confirm yet again.

d. Mail your invitations — time them to arrive one week in advance. Beware of the erratic delivery of bulk mail. Collectors are worthy of first class mail!

e. Each art professional should meet with the gallery director or owner individually to ascertain the number of holds, pre-exhibition sales, and confirmed attendees, one week prior to the exhibition.

f. Have a receiving line to greet everyone. If most of the attendees are not prior buyers (as might be the case for a brand new locations), then have each person sign a guest book with a place for their name, address and phone number.

g. Enjoy your exhibition! Prioritize your time based on prior buyership and highest potential for short term results. That is not to say all of your attendees are not worthy of attention. Rather, having done the phone work up-front, you can always pay close attention when close attention is genuinely needed and required by the collector.

h. Each art professional should meet with the gallery director or owner individually to set up a phone follow-up schedule to call everyone who attended and expressed an interest to buy, but has yet to buy.

i. Congratulate yourself for a job well done. You guaranteed yourself a successful exhibition.

2. Exhibition Protocol

a. In order for each art professional to attend the exhibition the following should be required:

> i. Sign up a predetermined minimum number of clients who will possibly attend the exhibition as compiled on their Exhibition Organizer forms.

> ii. Mail a predetermined minimum number of pre-exhibition letters.

> iii. Call everyone listed on their Exhibition Organizer forms.

iv. Mail a predetermined minimum number of invitations.

v. Call, a second time, all those who expressed an interest after the initial call.

vi. Each art professional should adopt a fall-out strategy with the gallery director or owner (based on prior results) such as: *If I start with 50 invitees I can count on 10 attendees with 3 sales and 2 holds.* The actual predetermined minimum numbers of invitees should be determined by the gallery director or owner and can vary from art professional to art professional and from exhibition to exhibition. Exceptions can be granted based on special and verified circumstances.

In the event the criteria are not met, the gallery director or owner must determine if exceptions are to be made in order to permit those art professionals to attend the exhibition. There will be times, of course, when the exhibition attendees expected far out number the available art professionals who have met the criteria. In those cases, the gallery director or owner should make rules and arrangements to minimize confusion (commission splits, client ownership, smoothly flowing greeting lines, color coded name tags for clients, etc.).

3. Pre-Exhibition Phone Techniques

The following pre-exhibition phone contact outline is provided to assist art professionals in developing their own special method of dealing with collectors prior to an exhibition. Review the basic approach, then tailor it to your style and clientele.

a. Call *everyone* you have invited to the exhibition to confirm attendance.

b. Determine the best time to call for each client (for most people, all between 7 & 9pm or 8 & 9am).

c. Always introduce yourself immediately, then ask if this is a convenient time to call. If yes, continue — if no, ask if you can call at a more convenient time (don't forget to find out when!).

d. Tell them you are calling to confirm their attendance at the exhibition. Reinforce how fun and exciting it will be.

e. Be *direct* and yet *reassuring*: *I look forward to seeing you there! Can't wait to exhibition you the piece that will be unveiled — it's breathtaking!", Can I count on you two? I'm letting my General Manager know how many of my VIP clients are attending so we can have enough champagne!* [You may wish to close here.]

f. If you continue, firm up a sale! Describe the artwork in your own terms (remember *Fact-Advantage-Benefit*). Elaborate on those features that might be most appealing to that person (e.g. highly polished bronze, limited edition, high quality, symbolism and legend, size, best time to buy, etc.).

g. Reassure them of the features that are important to them.

h. Ask those closing questions!

4. A Clearly Defined Exhibition Protocol Ensures that:

a. Those art professionals who, in fact, follow-up will be given every opportunity to close their invitees (and avoid unnecessary commission splits). This enhances client satisfaction as well, because people prefer loyal consistent contact with their art seller. Without this in mind, clients may be bombarded by multiple unoccupied art professionals with redundant qualifying questions.

b. Clients will be treated with utmost dignity and respect for their time and interest in your artwork.

c. Your events will have a *class act* air about them that places you above the competition.

CHAPTER EIGHT

THE FUNDAMENTALS OF SALES ANALYSIS

Sales analysis is the key to creating effective promotions on an ongoing basis. You must, however, have some history in order to do your analysis. Once you have been in business for six months or a year, some form of sales analysis should conducted on a quarterly if not monthly basis. Savvy owners of new ventures, to be sure, may analyze their efforts by the hour but the kind of analysis I wish to share with you now requires some lengthy period of history.

Getting Started

First, you must make and retain good records. This can be accomplished manually or using a computer. The records should provide a series of good snapshots of your business — that upon close examination can help you spot trends.

The data you wish to track will depend on the type of art firm you manage and the nature of your clientele. Let's examine some specific scenarios that will allow you to make or fine tune your record keeping decisions.

For starters, you will want a complete record of all sales that deserve your follow up. Follow up includes an exhibition invitation or direct-mail offer that is followed by that all important phone call. You may wish to exclude low price point items like postcards and posters if they represent a small fraction of your dollar-volume.

Thus, a monthly summary of new sales can be a perfect starting point. The following are samples of five reports discussed in this chapter.

Report 1: Monthly Summary of New Sales

07/31/9X			NEW SALES REPORT - JULY				
			07/01/9X to 07/31/9x			SPLIT	
CLIENT NAME	INV#	DATE	TITLE	ART/FRAME		#1	#2
Furosho, John	A123	07/10/9X	Commission	32,000.00		75% KA	25% JP
Hudson, Paul	A345	07/10/9X	Flight Fantasy	19,245.00		50% NT	50% RT
King, Anna	A567	07/11/9X	Night Walk	8,700.00		100%	
			Continued with more such detail...				
	Totals:			$250,000.00		63%	37%

Report 2: Monthly Sales by Artist & Artwork

07/31/9X		SALES REPORT - ARTIST & ARTWORK - JULY						
				07/01/9X to 07/31/9X				
ARTIST	TITLE	CLIENT	A.C	DATE	INV#	SALE AMT	$PAID	QTY
NAMA	Commission	Evans, Paul	GT	07/01/9x	A101	1,200.00	400.00	1
NAMA	Poster	Gray, Tim	PQ	07/02/9x	A102	650.00	650.00	13
NAMA	Min.Pnt/WF	Pierson, Jill	RS	07/09/9x	A108	770.00	200.00	1
NAMA	Lady/Gld Blsm.	Stumpler, Matt	TL	07/10/9x	A111	2,800.00	269.00	2
NAMA	Hanayome	Azevedo, Chris	TS	07/14/9x	A123	3,500.00	93.00	2
NAMA	Flight Fantasy	Underhill, Larry	MN	07/18/9x	A234	10,640.00	6,955.46	10
NAMA	Lady, Asano	Smith, Kathy	GT	07/28/9x	A587	<2,500.00>	<500.00>	<1>
Gross Sales - Artwork						19,560.00	8,567.46	29
Cancellations $ Credits						<2,500.00>	<500.00>	<1>
Net Sales on Artwork						17,060.00	8,067.46	28
Miscellaneous						350.00	350.00	1
Net Totals for Artist						$17,410.00	$8,410.46	28

Report 3: Monthly Geographical Breakdown

07/31/9X		Geographical Breakdown - July						
				07/01/9x to 07/31/9x				
STATE	#CLIENTS	-%	$ VOLUME	-%	$-CLIENT	$Y-T-D	-%	
AZ	103	15.5	165,250.00	19.0	1,604.00	366,750.00	12.6	
CA	1,446	37.5	514,341.00	65.4	1,053.00	1,247,892.00	72.8	
HI	114	17.2	148,697.00	18.9	1,304.00	347,092.00	10.6	
IA	3	.4	1,400.00	.3	467.00	7,204.00	.5	
			Continued with more such detail...					
Totals:	2,083.00	100.00	50,429.00	100.00	58	2,010,205.00	100.00	

Report 4: Monthly a.c. Sales Report

07/31/9X

SALES REPORT - JULY CONSULTANT & ARTWORK
07/01/9X to 07/31/9X
DEBBIE SMITH

TITLE	CLIENT	PHONE	DATE PD	INV#	NET SALE	$PAID	QTY
Commission Pnt.	Evans, Raul	(601)553-1111	07019X	A0123	1,200.00	400.00	1
Poster	Reed, Robert	(213)662-4848	07029X	A0223	5,175.00	175.00	3
Min.Pnt.w/FOF	Hudson, Sue	(707)234-4321	07039X	A0345	5,770.00	200.00	1
Lady of G.B.	Summer,Lynn	(818)567-9876	07069X	A0456	2,800.00	750.00	2
Hana. Passion	Brown, Randy	(321)545-6789	07089X	A0786	3,500.00	1,200.00	2
Flight Fantasy	Sasa, John	(709)456-0987	07159X	A0897	8,640.00	4,955.00	5
Lady Asano	Kim, James	(980)867-4569	07289X	A0985	-2,500.00	-500.00	-1
GROSS SALES					17,085.00	7,680.00	14
CANCELLATIONS & CREDITS					-2,500.00	-500.00	-1
NET SALES ON ARTWORK					14,585.00	7,180.00	13
MISC.					350.00	350.00	
NET TOTAL DEBBIE SMITH ART + MISC.					$24,935.00	$7,530.00	
GALLERY TOTAL					$137,345.00	$92,323.65	

Report 5: Monthly Open Accounts

07/31/9X

OPEN ACCOUNTS - JULY 199X
DELIVERABLE ART for BARBARA JONES

CLIENT	TITLE	INV DATE	INV.#	INV AMOUNT	BALANCE DUE	LAST PAYMENT	OVER 90 DAYS
Edward. Paul	Commission	04179X	A0234	2,624.00	1,250.00	06159X	1,250.00
Ronald Robert	When Spirits Unite	05229X	A0345	5,458.00	2,187.00	06309X	2,187.00
TOTAL DELIVERABLE ART				$8,082.00	$3,437.00		$3,437.00

Twelve monthly summaries, in thirty day increments, will provide you with the snapshots you need to see what is moving in a specific time period, as well as who is selling it.

Make Better Buying Decisions

Next, look at the same information in slightly different ways. For example, if you carry numerous artists, look at specifically which multiple works or original styles are fast movers. That information will aid you in your buying decisions.

If you work directly with the artist, (as a publisher would, for example) then you can guide the artist with such finely tuned recommendations, *We need two more vertical composition style prints with the looser body language and cool colors.* After all, in the final analysis, whatever the market loves determines the success or failure of a piece (in business terms, anyway) so we may as well *listen* to our buyers and create (or buy wholesale) what they want to acquire.

Report 2, *Monthly Sales by Artist & Artwork,* gives you an idea of how to structure such artist related information. While history can't always predict the future, most certainly trends can be spotted to provide solid indications for test marketing your art and minimizing risk.

Make Better Roadshow Decisions

For many of my clients who sell to a *visitor market* such as a resort town or convention center market, it can be critical to monitor geographical breakdowns of your buyers. For example, if you are based in the resort town of Tiburon, California, and determined that 15% of your buyers are from Arizona (with an average purchase of over let's say $1600), you may easily justify an exhibition in the home of an important Arizona collector.

If you think this idea is far fetched, think again. Many of my most successful art galleries stage such exhibitions based exactly on such

information. In fact, not long ago, a gallery in Hawaii sent two senior art consultants to California, and in a four hour brunch (which the clients were invited to and paid for separately) they sold over $200,000 worth of art!

For any gallery that sells, in whole or in part to a visitor market, road exhibitions can be a significant profit center and add tremendously to the firm's bottom line. Review Report 3, *Monthly Geographical Breakdown*, for clarity of how the data could be displayed.

Make Better Direct Mail Decisions

Another purpose for the geographic breakdown report is to make your direct mail decisions more effective. For example, one of my clients determined that a large segment of prior buyers with a high average sale amount lived in the San Francisco Bay area. Furthermore, these buyers loved a particular impressionist artist known for his land and seascapes. It was obvious that an impressionist style print by this beloved artist of the Bay area would be a good bet. And sure enough, the selected print sold extremely well to this collector base.

Manage Your Sales Team More Effectively

Often when I first begin working with clients I ask, *Which collectors are your art consultants calling in follow-up to this mail-out?* And the response is usually, *Well, I don't know; let me go ask* **them!**

Well, let's turn that around! As the owner (or gallery director) you should not be asking for such information as much as you should be directing specifically whom should be called and by what date. When you provide your art consultants with a list of all prior buyers who have spent over $2,500 and have at least one impressionist art piece, then when a new impressionist style print is published, it simply makes the best business sense to call these individuals first. Such a list should be printed out. You should meet with the art consultants individually to see how well they are

progressing with their calls. Report 4, *Monthly Art Consultant Sales Report,* reflects one arrangement of that information.

Do not misunderstand, I am not saying hand your sales team a list and say in an insensitive manner, *Do it!* That brusque style is counter-productive. Rather, you ask the art consultants how many prior buyers they plan to call to maximize their chances of success — then supply the list so you have a meaningful benchmark that will assist your team in attaining success.

The bottom line is if a person presented with such an obvious tool that essentially guarantees their success if used but they refuse to use it, something is awry. Either they require added confidence in phone selling, the artwork, the artist, or the firm. One last possibility is that the person may be fooling him or herself (as well as a gullible manager) about desiring success in art sales.

Quite often my clients are incredulous at this last possibility. The thinking is, well the art consultants are paid primarily on commissions earned from actual sales. Surely, if someone decides to become a commissioned sales person, they will do what will maximize their success. Well, my experience tells me that we humans can do some of the strangest things — not the least of which is that last scenario. I have found that many people are attracted to the gallery employment for reasons and perceptions such as the following:

- a classy, clean, culturally enriched environment

- they are frustrated or ambitious artists seeking to be discovered

- a high guaranteed base salary which allows the person flexibility

- tales of big commissions when large art sales occur

- the misconception that selling art is easy for anyone

- art exhibitions are glamorous and require little real work

- they are blessed with the gift of gab and fooling themselves about the organization required to do good follow-up and only work the floor.

As the owner or gallery manager, it behooves you to weed out those on your sales team who are not heading for success for the above or any other reason as quickly as possible. Make no mistake about it, such art consultants are *burning up territory* — a phrase that describes the methodical destruction of your firm's potential collector base. You are doing no service to them and are harming yourself and your other consultants.

Afterall, when a person follows my advice only part way and tells the potential collector, *I'll be calling you to confirm your attendance at our next show* — but doesn't — obviously that potential collector will more than likely take their business else where..

In addition to accelerating needed attrition, another example of guiding your team has to do with collecting on lay-a-way accounts. While many art galleries are making effective use of financing such as that which is offered through Beneficial Finance, GECC, and others — there are still many collectors who prefer the lay-a-way. This is particularly true for small business owners who may wish to acquire the art out of their cash flow. When they have a particularly good month, they will send in a couple of payments but do not want to run the risk of ruining their credit. Therefore, a lay-a-way agreement with some flexibility and one where the payment history does not get reported to major credit bureaus, becomes a desirable way to finance a big ticket discretionary purchase.

You will want to encourage the proper offering of such an arrangement because it will significantly expand your sales. Throughout history, these kinds of arrangements have always worked between one small business to another. On the other hand, you do not want to end up with a collections nightmare.

It is not uncommon for a $2 million a year art gallery to have $200,000 to $300,000 on lay-a-way. Effectively managing these open accounts can

have a significant positive impact on your cash flow. Further, since most art galleries only pay commissions on art paid-in-full, assisting your art consultants with open account collections will directly affect their pocket book. As we look at this in purely human terms, the art consultant calling a delinquent account is really chatting with a business associate who will keep them posted on their cash flow situation. Staying in touch in this manner from month to month further strengthens the buyer-seller relationship and supports the creating collector way of doing business.

The idea here is to provide the team with a focus: *Here's a list of your open accounts — if you make it a priority, this can mean $1500 more in commissions earned this month.*

Review Report 5, *Monthly Open Accounts.* I think you will see how this may work well for you. As you manage your open accounts please keep in mind, the longer the lay-a-way, the greater the chance of cancellation and vice versa! So, when you assist your art consultants in timely collections, you will help guarantee yourself more lay-a-way sales will stick. This, in turn, will support your primary goal of building a collector base.

In summary, I hope this sales analysis overview has given you some ideas or reinforced ones you already have. For many of us, the challenge is not so much recognizing that sales analysis is valuable, but more that we don't take the time to obtain or organize the information to analyze it. This chapter should stimulate your interest in obtaining and organizing your own sales data. When properly presented your future decisions can take your art firm to greater heights.

CHAPTER NINE

STAFF EVALUATION

Staff evaluation is a valuable exercise in that it reveals weaknesses and strengths among those upon whom you depend. When weaknesses are discovered, you can institute appropriate training and/or motivation programs.

The *Appraisal Program Structure* flow chart below illustrates the steps in conducting an appraisal program. The evaluation forms which follow are meant as a guide. Adopt them as is or modify them as may be appropriate for your gallery.

APPRAISAL PROGRAM STRUCTURE
The Individual's Goal Setting Process

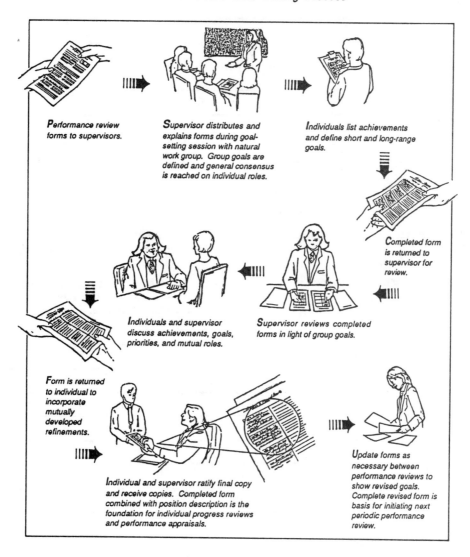

Performance review forms to supervisors.

Supervisor distributes and explains forms during goal-setting session with natural work group. Group goals are defined and general consensus is reached on individual roles.

Individuals list achievements and define short and long-range goals.

Completed form is returned to supervisor for review.

Supervisor reviews completed forms in light of group goals.

Individuals and supervisor discuss achievements, goals, priorities, and mutual roles.

Form is returned to individual to incorporate mutually developed refinements.

Individual and supervisor ratify final copy and receive copies. Completed form combined with position description is the foundation for individual progress reviews and performance appraisals.

Update forms as necessary between performance reviews to show revised goals. Complete revised form is basis for initiating next periodic performance review.

Gallery International
Performance Appraisal Form

Name _____

Job Title _____

Immediate Supervisor _____

Department	Hire Date
Period Covered	Appraisal Date
Time in Current Position	

1 Quality of Work

☐ Consistent high degree of accuracy and neatness; very reliable; no rework; does not need supervision.

☐ Exceeds minimum requirements of accuracy/ neatness; very few errors; little rework; needs little supervision.

☐ Meets minimum requirements of accuracy/ neatness; some errors; requires rework; needs moderate supervision.

☐ Does not meet minimum requirements of accuracy/ neatness; many errors; always requires rework; needs significant supervision time.

REMARKS: _____

2 Attendance and Punctuality

☐ Excellent attendance and on-time record. Consistently very dependable. Exceeds 98% attendance/on-time.

☐ Seldom absent or tardy. Dependable. Exceeds 96% attendance/on-time.

☐ Occasionally absent or tardy. Reports absence or tardiness in advance. Exceeds 94% attendance/on-time.

☐ Absent or tardy frequently. Does not always report it in advance. Does not achieve 92% attendance/on-time.

REMARKS: _____

3 Job Knowledge & Skills

☐ Demonstrates exceptional knowledge/skills. Consistently provides creative solutions; needs no direction.

☐ Good knowledge/skills. Provides creative solution to some problems; needs some instruction on assignments.

☐ Meets requirements for knowledge/skills. Solves problems with standard approaches; needs instruction.

☐ Inadequate knowledge/skills. Does not research material unless asked; needs help to solve standard problems.

REMARKS: _____

4 Interpersonal Relations

☐ Implements improvements that significantly improve workpace and output. Good rapport with everyone.

☐ Makes recommendations to management that improve workpace and output. Quick to offer assistance.

☐ Contributes evenly to the workpace with no disruptions. Offers assistance to others if asked; cooperative.

☐ Disrupts workpace and reduces team's overall productivity; promotes self-interest at other's expense.

REMARKS: _____

5 Creativity and Judgement

☐ Solves problems with no assistance. Reaches innovative conclusions to support goals; sought for advice.

☐ Solves problems with little assistance. Assists others with their problems; handles new assignments well.

☐ Solves problems with some assistance. Assists others when asked; handles new assignments reasonably well.

☐ Does not solve adequate quantity of own problems. Does gather data but unable to draw conclusions.

REMARKS: _____

6 Time Utilization and Planning

☐ Completes most tasks early. Updates management of progress and offers solutions when target dates are jeopardized; anticipates/ prepares for potential snags.

☐ Completes most tasks on time; some late. Updates management on progress. Monitors workpace reasonably.

☐ Completes all tasks on time; some early. Updates management on progress. Monitors own workpace well.

☐ Misses deadlines. Establishes progress check points with management only upon request.

REMARKS: _____

7 Cost Effective

☐ Recommends, implements innovative ways to reduce costs. Monitors and evaluates project's cost progress on own.

☐ Meets project budget goals. Monitors overruns on own.

☐ Assists in preparing project budgets; monitors on own. Justifies all budget deviations.

☐ Misses project budget objectives. Does not monitor overruns unless asked.

REMARKS: _____

8 Overall Rating

CONSIDERING ALL FACTORS, check the definition which best describes this staff member's overall peformance during this review period:

☐ OUTSTANDING - Results achieved far exceeded requirements.

☐ SATISFACTORY - Results achieved met the requirements.

☐ VERY GOOD - Results achieved consistently exceeded requirements.

☐ UNSATISFACTORY - Results did not meet the requirements.

9 Counseling Summary

INDIVIDUAL'S STRENGTHS:

☐ _____

☐ _____

☐ _____

☐ _____

SUGGESTED IMPROVEMENTS:

☐ _____

☐ _____

☐ _____

☐ _____

10 Discussion

A. *What does staff member feel is necessary to improve his/her efficiency?*

B. *Is staff member satisfied with his/her job?*

C. *What can or should be done to improve the individual's value as a staff member?*

Goals & Planned Results

Goals & Objectives:

Results & Comments:

COMPLETED BY:

COMPLETED BY:

COMPLETED BY:

COMPLETED BY:

CHAPTER TEN

AS YOUR ART FIRM GROWS

A positive consequence of being successful is that your art firm will grow. Every so often, the changes associated with growth are not welcome. This is often the case if the changes come too quickly for a gallery that started as a small family business. If, however, you have been conscientiously involved in the planning and execution of exhibitions and promotions, you will be able to monitor and control your growth by slowing down any particular phase of your plan.

My experience has been that the majority of business owners welcome growth even if there are growing pains. I hope the information in this chapter will help ease whatever growing pains you may experience so you can enjoy your success as much as possible.

Developing Your Sales And Support Team

One key to successful growth is to be able to effectively clone yourself. One person — regardless of how much talent, savvy, experience, and energy they possess — can only do so much. With approximate clones, you can multiply your results. I say approximate clones because, with experience, you will begin to hire people who possess their own unique strengths that parallel and complement your talents. The enlarged staff becomes a synergistic team. The results will be superior to the results you could achieve on your own.

Recruitment

I have found that the best way to recruit good people is not through ads but through word-of-mouth. The success of this approach depends on your determining, before commencing to recruit, the skills, personalities, and background you require. Once having made those decisions, you can begin to spread the word — your accountant, banker, insurance broker, landlord,

realtors, and trade contacts may be aware of a prospect. In addition you should be on the look out for people in various service industries. Here, you have to be discreet and remain true to your own ethics. But, I have found that as long as you are talking to adults, a simple hint will suffice. For example, two of my clients, a gallery owner and his wife were served in a restaurant by someone who impressed them. She was a young woman in her early twenties and exhibited charm, wit, and intelligence. While this young woman knew absolutely nothing about the art industry, my clients felt that they should drop a discreet hint.

In that kind of scenario, a discreet hint could be worded as follows, *My wife and I have really enjoyed having you as our waitress. Thank you so much for the excellent service. By the way, I am in the art business and if you know anyone who might be interested in becoming an art consultant, let me know.... here's my card. If your friends are half as personable and efficient as you are, I want to talk with them.*

The conclusion to the story was that the young woman called and was receptive to the extensive training my clients provided. In only eighteen months, she turned out to be one of their most valuable employees. By the time this books was written she had been promoted to a key sales management position.

I have utilized the word-of-mouth method of recruiting myself for my own companies as well as on behalf of my clients. It works! The best example I can give you is when I dropped a discreet hint to someone in the process of selling me a cellular phone. She had come to a sales appointment with my partner who had called to say he was running very late — could I meet with the salesperson. I begrudgingly did. As I observed this young woman in action, I could see major talent, ability, and potential. I dropped a discreet hint at the conclusion of her presentation — *We have an opening right now for an administrative assistant and we are looking for a good person. Can you think of anyone that you might recommend that has a similar presentation style to your own? If you do, please give me a call.* The young woman called me the next day, I formally interviewed her, and she has been a valuable staff

member ever since. In fact, Lori Tamai has gone on to be the General Manager of my art wholesaling business. She is an effective manager, efficient project coordinator, excellent voice to the firm's public, and much more. She has earned the respect of everyone who works for her and with her.

In my view, the best way to have a superior staff is to recruit, train, and develop them yourself. If you must use the newspaper, which I certainly have done at times, then write ads that reflect not only the job content but also the potential of the position. Also, keep in mind, that people are looking for more then just a pay check. They will want to work for you because of that initial good rapport, the potential for a future, and the opportunity to grow. As long as you hold up your end of the bargain, your staff will remain loyal.

Staff Training And Development

Training and development of your staff is an ongoing endeavor. There is no such thing as a once a year seminar or motivational luncheon. Once you hire that first person, think in terms of a series of informative staff meetings, outside seminars, instructional videos, recommended books and trade publications. I particularly encourage you to bring in outside trainers to conduct workshops that your staff will find informative and inspiring. My consulting practice revolves around conducting such workshops and developing educational materials. Word travels fast, if my work and that of other trainers did not result in increased sales we would soon have no clients. There is an enormous body of objective data that strongly supports the view that third party training directly results in greater sales and profits.

Since I have personally been involved in the professional growth and development of literally thousands of people, I can assure you of the mutually rewarding aspect of these endeavors. It is a great feeling to assist someone in reaching their potential and making the best of their talents. In sales, it is very rewarding to also see a person (paid with incentives and/or

commissions) to begin to realize some of their highest aspirations — a trip abroad — children in private schools — a new house — a lengthy cruise — or a foreign sport car.

CHAPTER ELEVEN

MAKING YOUR DREAM THE REALITY

Someone wise once said, *Belief is the knowledge that we can do something. It is the inner feeling that what we undertake, we can accomplish. For the most part, all of us have the ability to look at something and know whether or not we can do it. So, in belief there is power — our eyes are opened — our opportunities become plain — our visions become realities.*

Those powerful words remind us of what we all hope to be true but often doubt, particularly when it comes to applying this wisdom in our own lives. Perhaps your spouse or other family members are less than encouraging, the economy is less than robust, or you just suffer from nagging fear as you pull yourself up to newer heights. Well, regardless of what is holding you back, keep your eyes on the prize.

There have been numerous studies completed on the psychological, educational and financial backgrounds of the top 10% performers in various professions. And invariably, the single most important distinguishing factor is persistence. That's right..... persistence. Certainly there is a lot to be said for business planning, organizational systems, market analysis, etc. But, all things being equal, and even when some other aspects are lacking, it is the person who perseveres that stands the greatest chance of succeeding.

One technique successful people do use that makes persevering more enjoyable is, in fact, planning. What planning does for the human brain is to literally provide an almost hypnotic reality that fools us into behaving as though our plans have already come to fruition. Think about the power of this!

Psychologists have known for a long time, for example, that the brain does not distinguish the difference between a past, future, current, or imaginary event in relation to our physiological reaction to the thought. Consider the following for a moment — When we have a nightmare, don't we awake trembling with fear? When we smell an old flame's cologne,

don't we turn to see him? And when we hear that old song from our high school prom, don't we feel his/her arms around us as we sweep once more across the dance floor?

Anthony Robbins wrote a handy reference guide entitled, *Unlimited Power*. It cites numerous studies from the clinical psychology arena that suggest that our brain sends messages to our nervous system to behave according to what we think! If we think there is a fire in a crowded auditorium, chances are we will panic and run — regardless of the actual circumstances.

Similarly, if we create and retain a mental image of a future, with successful occurrences of events, we will behave as though our success has already arrived. This will permeate everything we do. It will be a positive influence on how we interact with artists, publishers, our collectors, our spouse and other family members and ourselves.

One study of a Yale graduating class helps to substantiate these ideas. Over thirty years ago, a graduating class at Yale was asked how many had long term written goals. Only three percent of them did. Twenty-five years later the graduates were contacted and it was discovered that not only did those with the goals do better than those without, but that the magnitude of the difference was astounding. The three percent with long term written goals had amassed more financial wealth than the other ninety seven percent combined! Psychology experts, as do I, believe that our ability to stay focused on our ultimate goal helps to create and sustain the mental, physical, and emotional energies required to reach high levels of success.

I could share countless examples of how well this technique works. Long term planning when coupled with other methods (such as short term planning, modeling, affirmations, etc.) can empower the human spirit with almost invincible will. That, in turn, will permit you to take full advantage of every opportunity you create for yourself and equip you to persevere through any storm.

In my own experience, the vision of a better life while in the midst of abject childhood poverty, sustained my every waking moment. In addition the ravages of alcoholism created a virtual war zone in my home. But through it all, I just *knew* that one day I would have a prosperous career, a lovely home and family, my own office and a flexible schedule. I projected that onto that big screen in my mind. I saw it — I felt it — I experienced it — decades before it actually occurred.

Then, step by step, I planned the shorter range goals that I felt were necessary to achieve my longer range goals — the mechanical engineering undergraduate degree — the M.B.A. — the technical marketing experiences and management of multi-million dollar budgets — and finally the honing of people management skills. All this occurred prior to my taking the entrepreneurial plunge.

Allow me to provide a specific example. On July 9, 1983, I wrote the following ten year goal for myself — *Have national recognition as a leading business advisor and organizational development specialist.*

Well, I didn't just sit back after writing such a lofty goal and wait for things to happen — I proceeded to network and execute consulting projects that put me in front of major players. In short, my day to day activities led me straight to my long term dreams because every day provided me the opportunity to take one step closer. A bonus was that instead of taking ten years for me to achieve that goal, it only took me five years.

The Visionary Leader

The visionary leader, of course, must do the same thing but on an even broader scale. The stakes are higher because you are planning and affecting the lives of others as well as your own. While team members may come and go, the best tend to stay. They will look to you to expand their day to day challenges so a wonderful meshing occurs . . . that of the firm's long term results and their own professional long term goals. You must first

project that future success onto your own mental screen and then assist your staff in developing their personal vision.

One tool to facilitate that goal is to write mission statements that depict the firm's philosophical and ethical orientation while simultaneously expanding on the visionary outcomes. The mission statement should not be written in a vacuum but rather with the key participants. It should evolve over time to reflect the changes that are bound to occur and should always be indicative of a high purpose that transcends the every day. This is what inspires us as human beings.

The following is an excerpt taken from my art wholesaling firm's *Policies and Procedures Manual* and was written with input from the key participants in the firm:

> Our mission is to *bring art to the people*. This mission is the driving force behind all that we do. Our endeavors are dedicated to bringing the world of beauty and enrichment to those who have not been able to enjoy fine are because the traditional art marketplace affords limited access and lacks the capacity to provide personalized individual attention.
>
> With this mission in mind, *The Fine Art Network* works tirelessly to develop a national network of independent art dealers who are the field workers in bringing about a dramatic change in the way the public interacts with art. Through extensive training and support, *The Fine Art Network* makes it possible for independent art dealers to introduce their family, friends, neighbors, and business associates to the joys of collecting art and experiencing the beauty and inspiration which emanates from these wondrous works.
>
> As *The Fine Art Network* grows into a larger and more vigorous business, we pledge to maintain the following philosophy:

We pledge to represent and offer the very best artworks and artists we can find. Our goal is to provide truly great art by regional, national, and internationally acclaimed artists.

We believe in the personal dignity of each individual and strive to share this belief with all who we meet.

We belong to a single spaceship earth, and as passengers we must do our utmost to contribute to the safety and well-being of all others sharing the same vehicle.

We believe in our keeping a strong position on environmental conservation — that all art works offered by *The Fine Art Network* will be derived only from materials which do not exploit endangered species, and are known to be obtained and produced in an environmentally sensitive manner.

While that mission statement may seem overly sentimental to many hard edged business people — I have found that from the Steve Jobs (Apple Computers) to the Stephenson Higa (Images International of Hawaii) — from Thomas Watson (the founder of IBM who named his company International Business Machines at least a decade prior to becoming international) to Robert Chase (Merrill Chase Galleries) — from Walt Disney to Robert Lewin (Mill Pond Press) — the truly great companies of the world are lead by passionate business people who believe they are making a difference in the world. The people who stay and devote themselves to the mission are those who align themselves not just with requisite job duties, but with the passion that makes the day to day worthwhile.

Remember the speech that John F. Kennedy delivered that propelled America's race into space? He proclaimed a national mission to become the first country to land a man on the moon and have the person return safely back to earth. What a piece of blue sky dreaming — yet he mobilized an

entire generation of scientists who successfully achieved this monumental goal.

Go ahead, allow yourself the luxury of dreaming. It is the stuff of visionary leadership when backed up with the many other tools available to business people. Go ahead, decide to change the world — make it a better place for future generations. Tie your life's ambitions to your day to day endeavors and each moment will take you closer to your dream. *Just Do It!*

Once the vision has been created — the long and short range planning completed the moment of truth will be rudely thrust upon you. Ask yourself, *Will what I accomplish today take me a step closer to achieving the dream?* You know, on July 9, 1983, I not only wrote down my ten year goal, I went backwards in time and wrote seven year, five year, three year, two year, one year, six month, three month, one month, and one week goals. I got it right down to my things to do list, and then I went out and did it!

I don't mean to suggest for a moment that I unerringly pursued my goals. I assure you, there were many detours, dead ends, re-routes, and plain old forgetfulness. But by having my mission, plan, and goals, the path was far straighter and the distance far shorter than it otherwise would have been.

Did you know that most people spend more time planning the vacations than they do planning other aspects of their lives! As a result, most of us get to the end of the road thinking, *Is this all there is? Where did the time go?*

The moment you latch onto your vision, coupled with dedicated action, you will create an unstoppable engine. As long as you direct yourself in the right direction, will get you to your destination — and lest you forget, remember to enjoy the trip because that, after all, is life.

Bon Voyage!

FORMS

Client Information

Name:_____

Address:_____

City:_____ State:____ Zip:_____

Phone (R):_____

Phone (O):_____

Fax:_____

Best time to call:_____

Communication Log

Date	Reason for Contact	Commitment Date(s)	Action Taken	Next Contact Date

Client Profile

Decision maker(s):_____

Current art collection:_____

Primary buying motive(s): Emotion ☐ Investment ☐ Decor ☐ Other ☐

Buying style: Impulsive ☐ Deliberative ☐ _____

Annual income (estimate/actual):_____

Important family members & business associates:_____

Important dates:_____

Other comments:_____

Purchase History

Date	Invoice #	Art work(s) Acquired - Artist - Title Description	Price	Layaway	Shipment Date

Art Sales Goal: $_____ Future Acquisitions:_____

For the year 19___ _____

Purchase History

Date	Invoice #	Art work(s) Acquired - Artist - Title Description	Price	Layaway	Shipment Date

Show Organizer

Art Consultant: Thomas Jones

Show: February 5th & 6th Hart Show **Date:** January 1, 199X

NAME / ADDRESS / PHONE	DATE CONFIRMED	ARTWORKS	SALES TOTAL	DEPOSIT IN FULL
Bob Smith 123 Rt. 1, Anytown, USA 12345 (234) 765-9786	1/1	Pre-Publish	$3,500	$500 Visa deposit to hold prices
		TOTAL		

Notes

INDEX